IMAGES
of America

NELSONVILLE

ON THE COVER: Pictured here is a steam engine used in the early 1900s on the Hocking Valley Railroad. The railroad not only provided service for those traveling to and from Nelsonville but also played a big part in the coal industry. Today the Hocking Valley Railroad is only used for tourism, but with a reminder of the coal and clay boom and all of the jobs it brought to the region to begin and sustain the town. (Courtesy of Christine Vischer.)

IMAGES
of America

NELSONVILLE

Lorinda LeClain

ARCADIA
PUBLISHING

Published by Arcadia Publishing
Charleston, South Carolina

Printed in the United States of America

Library of Congress Control Number: 2015937592

For all general information, please contact Arcadia Publishing:
Telephone 843-853-2070
Fax 843-853-0044
E-mail sales@arcadiapublishing.com
For customer service and orders:
Toll-Free 1-888-313-2665

Visit us on the Internet at www.arcadiapublishing.com

Dedicated in memory of my son Samuel and to the rest of my family and friends who have supported me during this project.

CONTENTS

ACKNOWLEDGMENTS

I would like to thank the Nelsonville Public Library (NPL) for letting me use most of the old photographs and postcards in their collection, the Athens County Historical Society and Museum (ACHS&M), Linda Westfall, Christine Vischer, Kory Gulley de Oliveira, and Bill Standish for providing me with even more interesting old photos and stories.

INTRODUCTION

The history of Nelsonville began around 1814 when Daniel Nelson and his family arrived in the area from Shrewsbury, Massachusetts. At a site nestled in the Hocking River Valley, Daniel Nelson decided to lay out a town of around 58 lots. Although Nelsonville started out with slow growth, it picked up when coal was discovered. Daniel Nelson died in 1835, before the boom years of his town began. George Courtauld, a wealthy Englishman, tried to start a town in the east end about a mile from Nelsonville called Englishtown, and although he started a post office in 1821, the town fell through when Courtauld died while on a business trip to Pittsburgh. His family, who had come over with him, decided to give up and go back to the family business that prospered in England. Daniel Nelson was then appointed postmaster of Nelsonville. Many early settlers started up businesses to help the town grow; Josiah Coe and Charles Robbins started flour mills on the river, and coal was discovered by James Knight, an immigrant from England.

The mining of coal in the region started as early as 1830, and by 1840 the canal was being built, which provided a great way to transport coal to other areas. Coal was not the only natural resource mined in the area. Clay brought many immigrants from England, Wales, Scotland, and later Hungry, Poland, and Czechoslovakia to this region because of all the jobs it and coal created. In the late 1860s and early 1870s, the Hocking Valley Railroad came to town, providing an easier and faster way to transport the coal and clay products. So began the decline of the canal, which ran where US 33 once went through town. Nelsonville's population grew, and it became known as the largest "Little City of Black Diamonds." Train spurs went off in all directions to the many coal mines of the area.

In July 1863, Gen. John Hunt Morgan, a Confederate officer, came through town on his infamous Morgan's Raid. Although only here for about two hours, he and his army of men swept through town, burning all but one canal boat and stealing horses and goods from stores and residents. Nelsonville never had a dull moment, from Morgan's Raid to shootouts and many mine strikes. Many coal mines popped up in the region, from small ones to large ones owned by men such as W.B. Brooks, Longstreth, Scott, Poston, and many more; all of the businessmen seemed to own a coal mine. In 1884, striking miners burned down the schoolhouse on the public square, and Pres. William McKinley came to town to smooth things over. Christopher Evans also lived in Nelsonville and was one of the founders of the Knights of Labor union during the coal-mine strikes of the region. Nelsonville also had many famous visitors in the late 1890s to early 1900s: Warren G. Harding, Theodore Roosevelt, and William Howard Taft were all visitors at the Dew House.

Stuart's Opera House, on the opposite end of the public square from the Dew House, brought entertainment to the town. The opera house was built in 1879 by George Stuart, who had previously operated a showboat on the canal until his boat sank in 1869. Stuart gave the community and visitors a place to enjoy a night away from the backbreaking life of coal and clay. Everything from school graduations, church events, and entertainers brought in from all around were held in Stuart's until it closed its doors in 1924 due to hard times. In 1997, Stuart's was given a new life

and is still going strong today, offering shows just like it did from 1879 to 1924. Many businesses have come and gone on the public square, but many of the buildings look the same as they did in the early 1900s.

In the late 1960s, Nelsonville became home to Hocking Technical College (now known as Hocking College), a small two-year college. Hocking College started out small but now has its own campus right outside of Nelsonville and a couple of branches in other towns. This has also boosted the population of Nelsonville and helped the town grow. The public square has become a mecca of small art stores and galleries and holds a sort of open house and street fair on the final Friday of each month. A lot of history can still be seen in the small town of 5,000 residents; the Hocking Valley Railroad still runs a tourist train, letting people see and feel what life was like in the boomtown era. There is still a hometown feel: it is easy to picture the old Central School on the square, alligators living in the fountain, or soap bubbles floating out the top. The streetcar running through downtown, the excitement of Morgan's Raid, and the miner's strike of 1884 can still be felt while taking a Sunday-afternoon stroll around the public square. Every August, the Parade of the Hills is held, a street festival for the old-timers who have left to come back and find old friends or just enjoy the warmth of their hometown.

One

BRICKS AND COAL

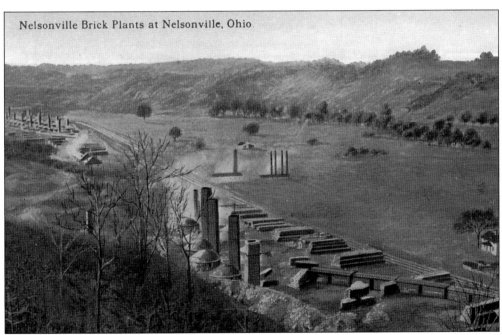

Nelsonville Brick Plants at Nelsonville, Ohio.

Nelsonville was a boomtown, not only in coal production but also in brick production. This postcard depicts the area once known as East Clayton. Many well-known bricks were manufactured in this valley, including the Star Brick, Nelsonville Block, Athena Salt Glazed, Hallwood, and the Hocking Valley Fire Clay. Many of Nelsonville's sidewalks and buildings were constructed with bricks from these plants. Now only two of the kilns survive for visitors to see. (Courtesy of NPL.)

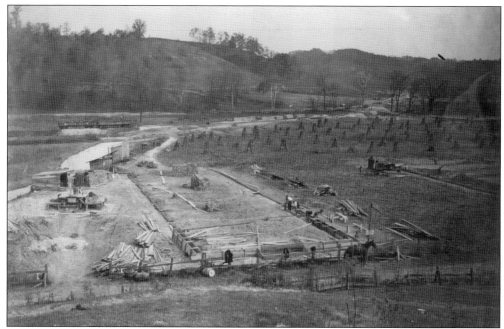

This photograph is the first of many showing one of Nelsonville's brick plants under construction starting in October 1906. The men are getting the lumber ready and working on the foundation. Notice the Hocking Valley Railroad spur in the background. Now, State Route 278 runs through the area. (Courtesy of ACHS&M.)

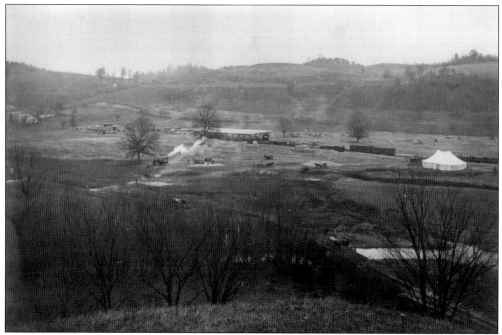

In the flat bottom land, a sawmill has been set up to get more lumber ready for the construction of the brick plant. This is in the area known as East Clayton. Brick manufacturing was in full swing at this point up until the 1930s, when all but a few plants closed up. (Courtesy of ACHS&M.)

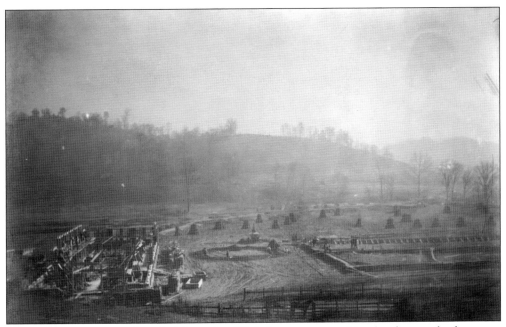

The building is coming along by November 1906; the men are working hard to get the frame up. Little did they know that in March 1907, a major flood would hit the Nelsonville area and the bottom land not far from the Hocking River. (Courtesy of ACHS&M.)

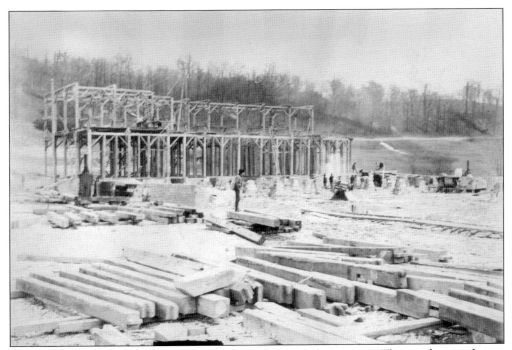

This looks like another building is going up in the East Clayton area. The weather conditions in January 1907 must have been favorable for them to get this far on the brick plant. (Courtesy of ACHS&M.)

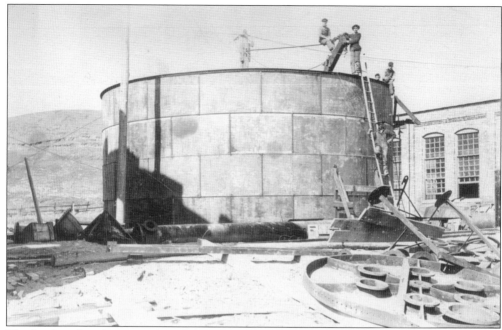

The brickyard tank was used in the production of the multipurpose building materials. With all of the new equipment, brick manufacturing probably became much quicker. By the early 1940s, all of these plants had shut down, with the exception of one in Haydenville. (Courtesy of ACHS&M.)

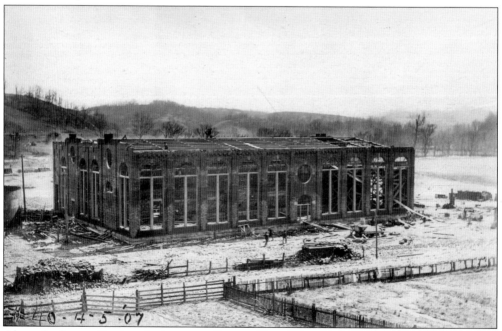

Along the factory district, also known as District 29 and East Clayton, were several brick plants. The first was the Athena brick factory, and the second produced the Hallwood and famous Star bricks. The third plant, located west of the old city waterworks and likely the structure pictured here, closed in 1928 when the brick boom was slowing down. (Courtesy of ACHS&M.)

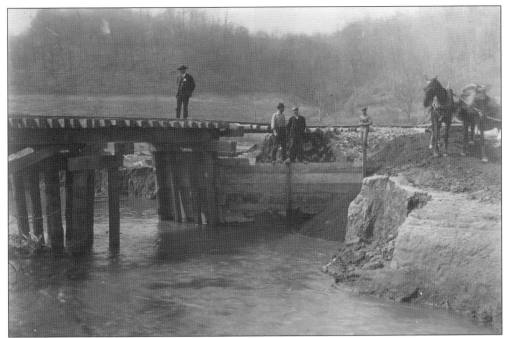

This photograph was taken not long after the March 1907 flood swept through Nelsonville on April 17, 1907. It looks like these men are surveying any damage that might have occurred. A caption relates that this was the bridge to the power plant; there appears to be some leftover debris from the high water near the top of the bridge. (Courtesy of ACHS&M.)

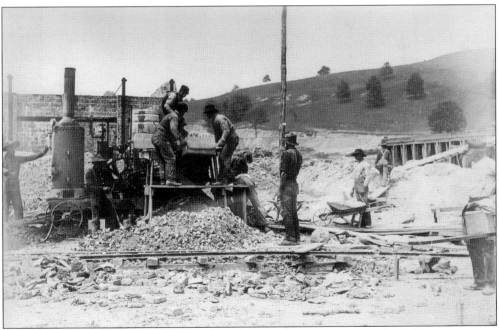

This photograph, labeled "concrete mixer," was taken on June 15, 1907. It looks like it was a very hot day and the men are hard at work on another brick building. Not much is left of the brick factories now, and it is hard to believe it is the same area. (Courtesy of ACHS&M.)

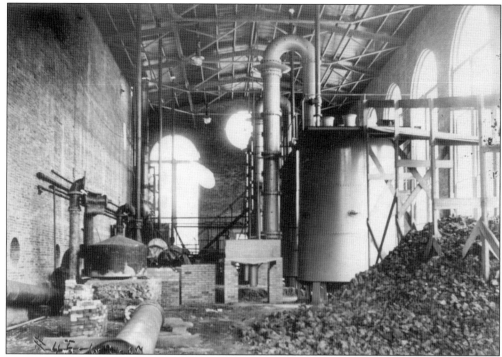

Pictured here in June 1907, the brick plant is now up, and inside it looks as if everything is ready to roll. Note the stacks of bricks on the floor. (Courtesy of ACHS&M.)

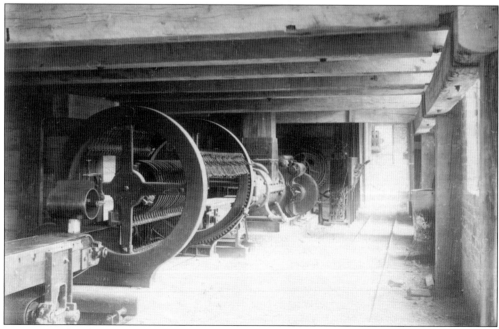

Here is another look at the inside of one of the brick plants. The huge piece of machinery was an automatic brick cutter, manufactured by the Mammoth Ohio Brick Machine E.M. Freese Company of Galion, Ohio. According to E.M. Freese newspaper advertisements, the brick cutter saved time and boosted production. (Courtesy of ACHS&M.)

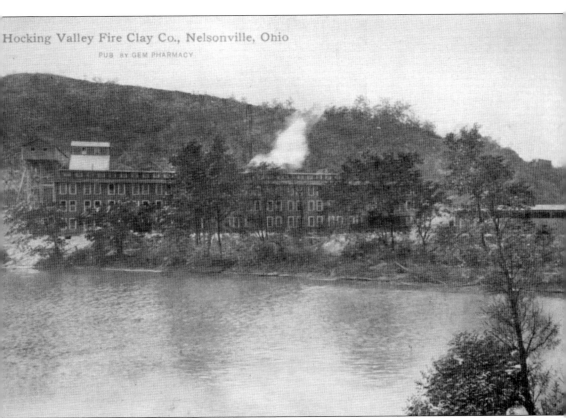

Hocking Valley Fire Clay Co., Nelsonville, Ohio

PUB BY GEM PHARMACY

The home of the Hocking Valley Fire and Clay Company sat across the river, to the north of Nelsonville. Bricks with the initials "HVFC," which can still be found, all came from here. Today, it is impossible to tell that a brick factory ever inhabited this spot, now home to the local Veterans of Foreign Wars post. (Courtesy of ACHS&M.)

The Flower design, very similar to the famous Star brick, was a product of the East Clayton Plant. Only a few remnants of the kilns stand today along State Route 278. In the late 1800s and into the early 1900s, the plants lined this whole valley. (Courtesy of NPL.)

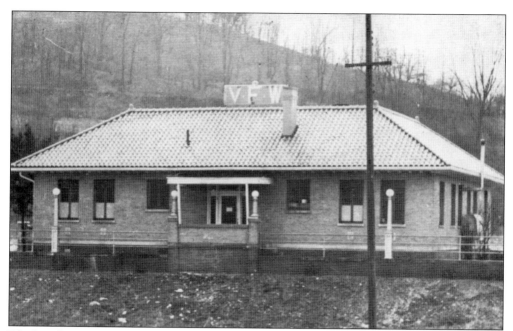

The Local VFW post now sits where Hocking Valley Fire and Clay Company used to be. On the hillside behind the building, some remnants of the manufacturing days used to be visible. It is hard to believe that not many years before, thousands of bricks were manufactured on this very spot. (Courtesy of ACHS&M.)

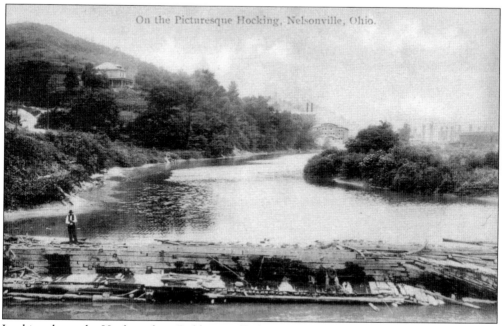

Looking down the Hocking from Robbins Mill, the stacks and kilns from all of the brick plants down through District 29 and East Clayton are visible. The brick factories brought in many immigrants, primarily from England, but also from Ireland, Scotland, and Wales. The five major plants employed an average of 120 men each. (Courtesy of ACHS&M.)

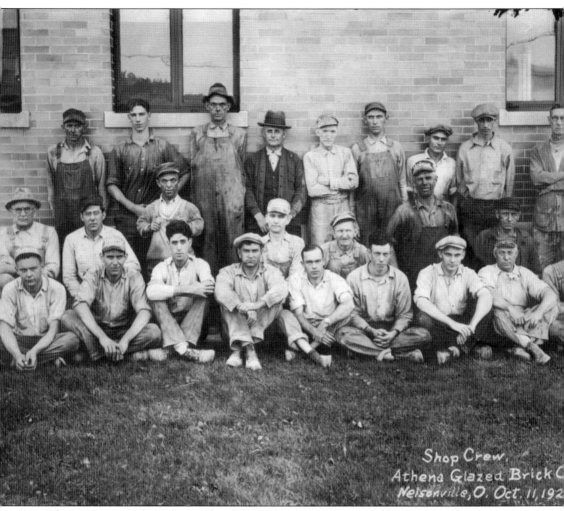

The employees of the Athena Glazed Brick Company are pictured here on October 11, 1928. It is possible that the man in the center of the back row is the plant manager, as he is dressed differently from the rest. The manager at that time was Carl Jewett, and to his left is James O'Harra. This plant, known as Plant No. 1, where the current VFW post now stands, was in operation until around 1940. (Courtesy of NPL.)

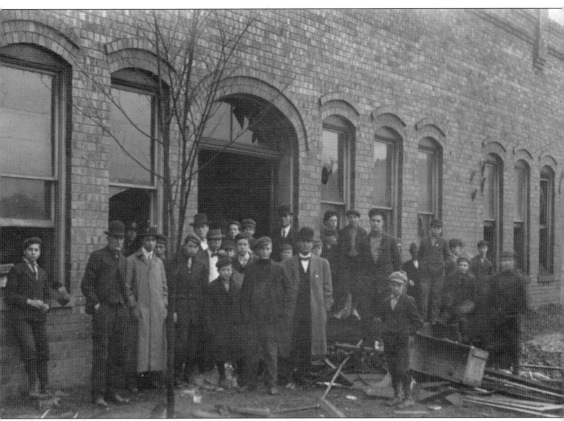

This photograph was taken the day after a flywheel accident at Nelsonville's electric-light plant. Night engineer Emmitt Krizer was killed in the accident on January 21, 1911. Only two people are identified: Tom Rodda, right of center standing on a pile of debris, and Howard "Whisper" Warner (1895–1964), next to Rodda, with a box in front of him. (Courtesy of NPL.)

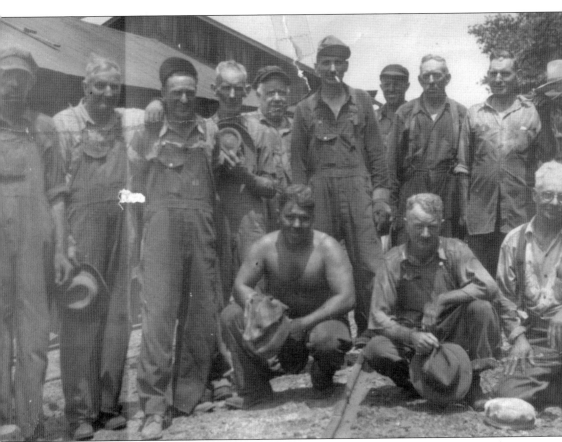

Pictured here around the 1940s are a group of coal miners from the Nelsonville area. The men are, from left to right (first row) Leonard Christian, Pappy Stewart, and Dudley Lowery; (second row) Merle Love, Dan Pancake, Ralph "Popeye" Devol, R. Glenn, John Farrow, Wilbur Duskey, Harry Stage, George Pancake, and George Lattimer. (Courtesy of Linda Westfall.)

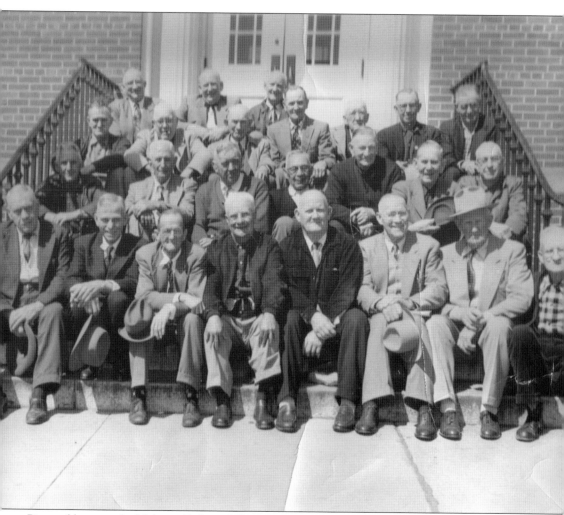

Pictured here on the Nelsonville Post Office steps in the early 1950s is a group of retired miners who belonged to Kimberly Local No. 3905. From left to right are (first row) Clarence Farrow, Sam Baker, Dub Lowery, R.C. Day, Sylvester Woodard, Frank Johnson, and Bert Davis; (second row) Lott Bricker, Milton R. Glenn, Grover Young, Jess Striblin, Will Devol, Wesley Hawk, and John Williams; (third row) Carl Lanning, Ed Dugan, Vern Cagg, Harry Dishong, Lew Windle, Sam Dishong, and Charles Hartman; (fourth row) Walter Swazee, Edward Conley, and Carl Pearson. (Courtesy of Linda Westfall.)

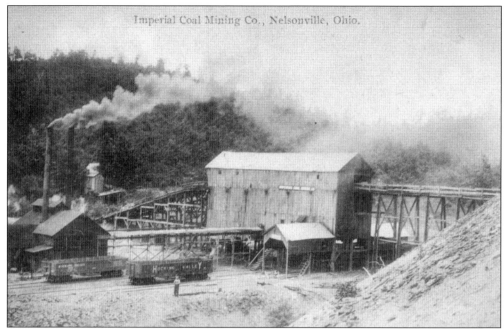

The Imperial Coal Mine was located near Myers Crossing along the Hocking Valley Railroad. Myers Crossing was the name for the area around Greenlawn Cemetery in the early 1900s. The Imperial Mine employed around 50 men. J.A Murphy and later William Murphy were the mine superintendents, and G. Barber served as the mine boss. (Courtesy of ACHS&M.)

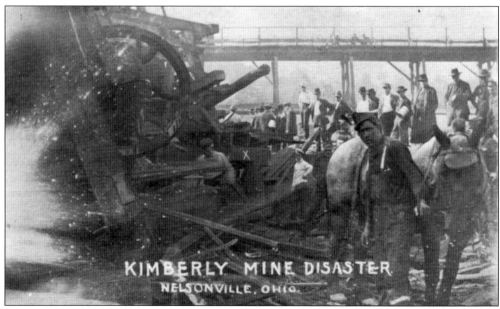

Not much has been written on the Kimberly Mine disaster. There were many small mining accidents throughout the coal boom; they were so common that many were hardly mentioned. In the mid-1870s, the chief inspections of mines were printed out every year and provided information on each mine, who was killed or injured, and who owned and supervised each one. (Courtesy of ACHS&M.)

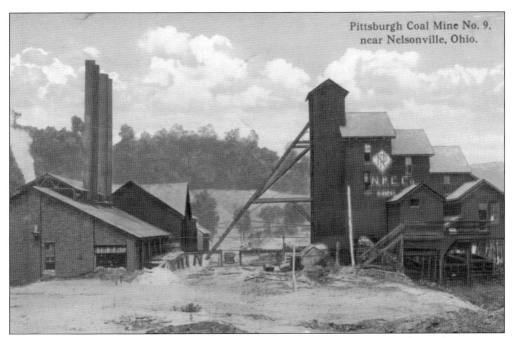

Pittsburgh Coal Mine No. 9, near Nelsonville, Ohio.

This photograph is of the Pittsburgh Coal Company No. 9 mine. Many of the coal companies were owned by men who did not live in Athens County. The New Pittsburgh Coal Company was based in Columbus, Ohio, as was the William B. Brooks mines, not to be confused with the Brooks family who own the Rocky Boot factory. (Courtesy of ACHS&M.)

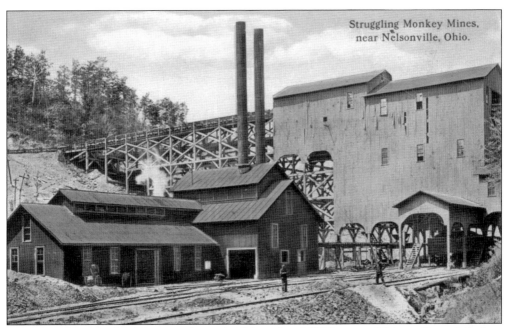

Struggling Monkey Mines, near Nelsonville, Ohio.

The Struggling Monkey Mine was located off State Road 278 between Nelsonville and Carbon Hill. It is rumored that the name of the mine came about because of financial troubles. According to the book *200 Years in Nelsonville* by Vore and Lawson, in 1910, a coal miner was murdered back in this hollow over some money he had won in a poker game. (Courtesy of NPL.)

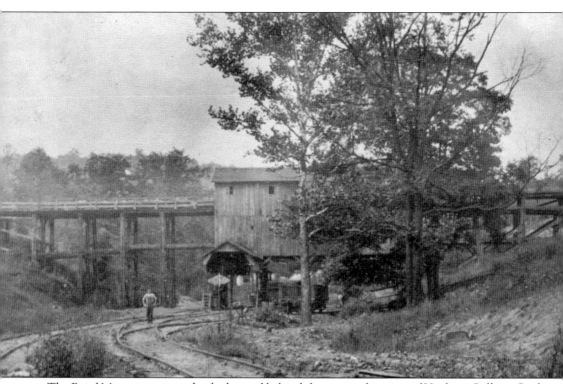

The Baird Mine was rumored to be located behind the current location of Hocking College. Coal mines covered pretty much every inch of this area. Many changed ownership and names quite frequently or only went by a number. (Courtesy of ACHS&M.)

Two

Businesses and Buildings

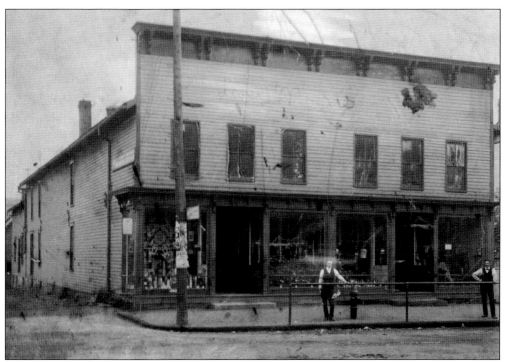

Cable's Hardware began in 1849 and is still in business today in the same building under the name of Savings Hardware. Originally started by Charles Cable on the corner of West Washington Street and Cables Alley, Cable ran the hardware store until his death in 1852, when it passed to his two sons Charles A. and Eugene J. Cable. Pictured here in the early 1900s, the two men outside of the store are identified as Frank Moore (left) and Will Gibson. (Courtesy of Bill Standish.)

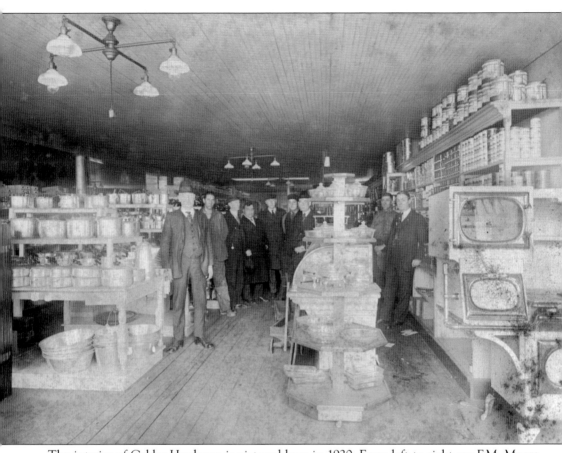

The interior of Cables Hardware is pictured here in 1920. From left to right are F.M. Moore, Louvinia Daft, H.L. Galvin, Rev. Leon Arpee, O.A. Rider, Owen Morrison, unidentified, George Barrows, and S.E. Dean. (Courtesy of Bill Standish.)

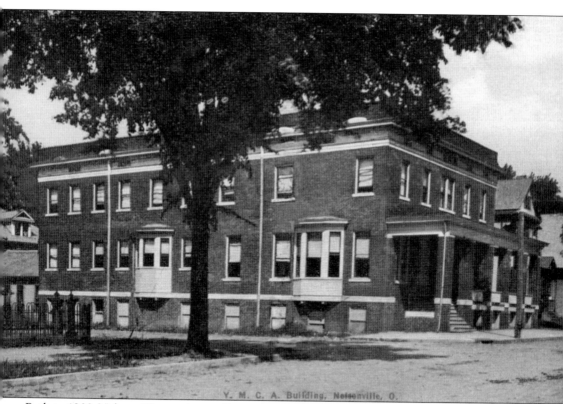

Y. M. C. A. Building, Nelsonville, O.

Built in 1908, Nelsonville was the smallest town in Ohio to have a YMCA. The Hocking Valley Railroad provided most of the money to build the YMCA in order to provide housing for its employees. Walter Hudson served as secretary and Al "Punk" Dilcher as athletic director until around 1931, when the Y closed for good. The basement housed a basketball court and small swimming pool; the main floor had two pool tables, a dart board, checkers, and other board games. On the upper levels there were 20 rooms to be rented out. After closing for good on July 1, 1931, it stood vacant until 1932, when it was briefly used as a headquarters for the National Guard during mine strikes. In 1940, it was converted into the Dr. Hubert Hyde Apartments. (Courtesy of NPL.)

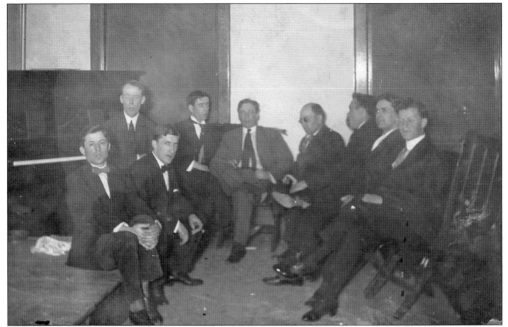

This photograph shows a group of men meeting at the Nelsonville YMCA; the back reads, "Taken in the Nelsonville Ohio YMCA by J.G. Percy on April 19, 1909." Two of the men could be Walter Hudson and Al "Punk" Dilcher, who dedicated most of their time to running the YMCA. (Author's collection.)

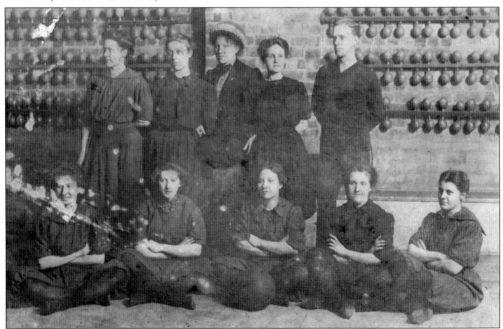

The YMCA was not just for the young men of Nelsonville, it was also open to girls and women on certain nights. The girls' basketball team practiced two nights a week, and there were gym classes every Saturday and two classes at night during the week for women, usually taught by Dilcher. (Courtesy of NPL.)

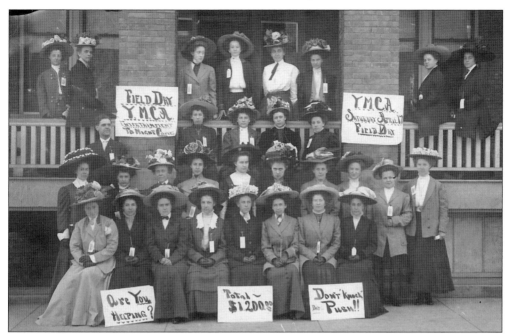

On April 17, 1911, the women of Nelsonville came together and raised $1,200 for the operating expenses during Field Day for the YMCA. It probably helped that the Y also reached out and offered classes not only to men but the women of the community. (Courtesy of NPL.)

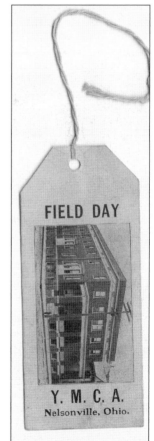

This tag dates to the April 17, 1911, Field Day held by the YMCA women to help with funding operations. In the photograph above, each woman has one of these little tags hanging from her clothing or hat. The YMCA hung on until July 1, 1931, when it closed for good. The building still looks very much the same and still has housing. (Courtesy of NPL.)

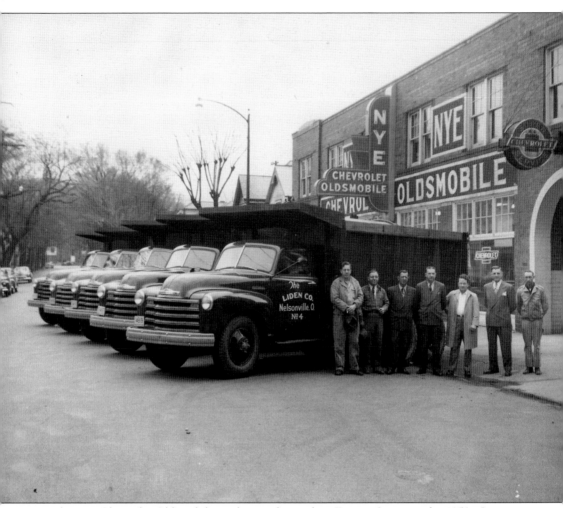

The Nye Chevrolet-Oldsmobile car lot was located on Fayette Street in the 1950s. It appears as if a fleet of trucks has just arrived for the Linden Coal Company. From left to right are Omer Lewis Standish, Roy Light (owner of Linden Coal Company), Mr. Nye (owner), Merlan Howson (salesman), Bob Light (Ray Light's son), and two unidentified men. (Courtesy of Bill Standish.)

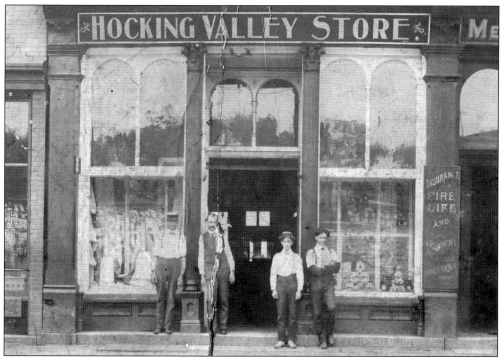

Originally built by John W. Scott in the early 1870s, the Scott/Spray Building has housed many different types of businesses; in fact, so different, it was featured in *Ripley's Believe It or Not!* in 1937. The first floor at one time housed a plumbing shop on one side and a restaurant that sold beer on the other, while the second floor was a church and the third held a dance hall. Later, a German man and Civil War veteran, William Gottlieb Spray, bought the building to run a saloon. During the Civil War, his feet had suffered a severe case of frostbite, and afterward they caused him so much pain only alcohol could ease his suffering. The 1875 atlas of Athens County features a sketch (below) that shows what the building looked like in the boom years. (Both, courtesy of NPL.)

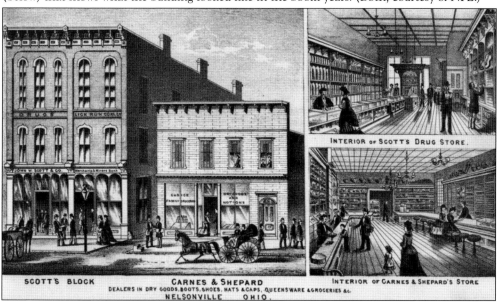

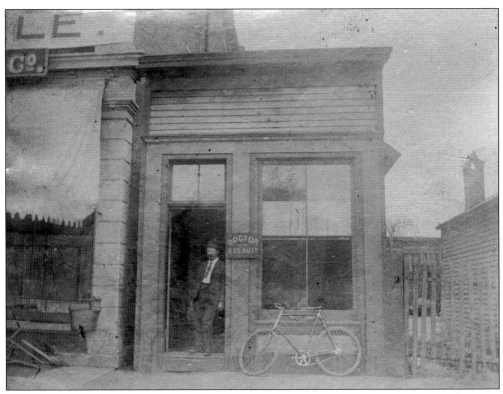

Dr. Samuel Edgar Butt (1857–1926) is pictured here in the doorway of his first doctor's office. He started out studying under Dr. W.E.W. Shepherd of Nelsonville, and in 1880, he graduated from the Medical College of Cincinnati, Ohio. After graduation, he worked with Dr. C.F. Gilliam until 1882 and also served as the city physician from 1880 to 1881. This office was possibly located on Columbus or Washington Street. (Courtesy of Christine Vischer.)

Located on Washington Street at the time, Solomon Charles Kontner ran a meat market. He also worked as a driver on the Hocking Canal and as a coal miner. His son Charles Kontner followed in his footsteps as a butcher. Later, this market moved to Fort Street. (Courtesy of Christine Vischer.)

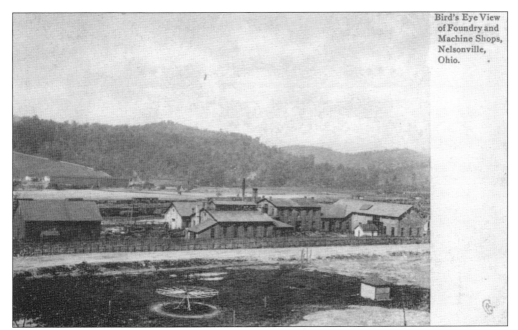

Bird's Eye View of Foundry and Machine Shops, Nelsonville, Ohio.

Nelsonville Foundry and Machine Company started in 1881 for the purpose of repairing machinery and constructing mine cars. In the foreground is an old horse track that was used between 1890 and 1906; at that time, the lots formerly known as the Longstreth Track were sold for housing. This area of the east end of town became known as Parkdale. (Courtesy of ACHS&M.)

The Nelsonville Foundry and Machine incorporated on April 4, 1881, under the leadership of Thomas E. Knauss, Charles A. Cable, Webb W. Poston, A.H. Carnes, and C.E. Poston. John W. Jackson was the president, and his son Robert H. Jackson was the secretary and treasurer. The lot is now home to a Speedway gas station, Domino's, and a small strip mall. (Courtesy of NPL.)

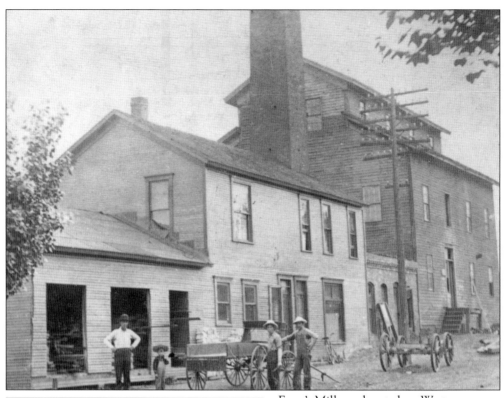

Freer's Mill was located on West Columbus Street, where the Methodist church now sits. Fred A. Freer was one of the proprietors of the mill and the son of George and Lydia Freer. Freer's Mill was started in 1898 and was later torn down, possibly in the 1950s or 1960s. The new Methodist church building was built in the early 1970s. (Courtesy of ACHS&M.)

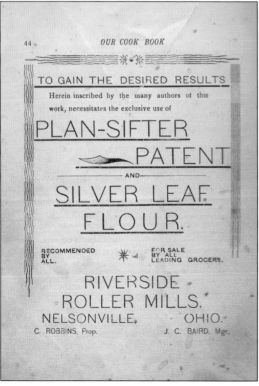

This advertisement was found in an old Nelsonville cookbook from 1896. Riverside Roller Mills was run by Charles Robbins and J.C. Baird. Robbins Mill sat along the Hocking River across the River Bridge that is now Hocking Parkway. The cookbook was compiled by the D.H. Moore Chapter of the Epworth League. (Author's collection.)

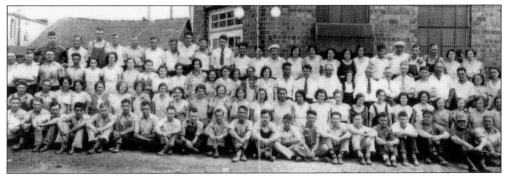

The William Brooks Shoe Company was incorporated in 1932. The original building started out as the McGovern Shoe Company, which after a short time went out of business in 1929. William Brooks and his brother F.M. Mike Brooks started up the Brooks company with 50 employees who turned out around 300 pairs of shoes a day. Today, the plant is now the Rocky Boot Outlet with three stories of merchandise and, of course, lots of Rocky boots. (Courtesy of Linda Westfall.)

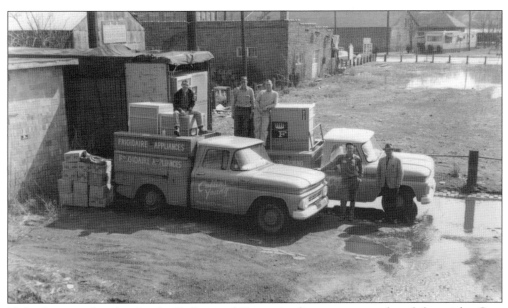

Unloading merchandise for the Collins and Young Appliance store are, from left to right, Curt Wolfe, two unidentified men, John Collins, and Gene Young. Collins and Young were the owners of the store, located on West Columbus Street. (Courtesy of Linda Westfall.)

Nelsonville was home to many saloons and bars scattered all through town. One of the few left is the Mine, located uptown. Some of the old buildings survived into the 1980s, such as this one, called simply the East End Tavern, located on Poplar Street. This photograph was taken shortly before it was razed in 1980. (Courtesy of ACHS&M.)

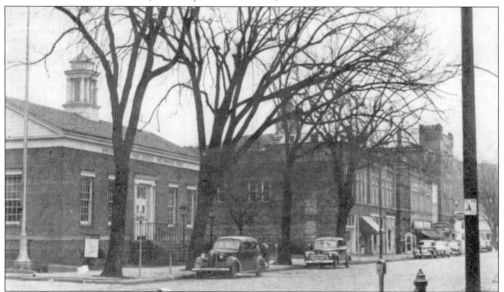

In August 1936, ground was broken for a new post office for Nelsonville. The grand opening was in May 1937; Charles G. Pritchard is given credit for pursuing the new building. The Hon. L.J. Eberle became postmaster on July 9, 1935. Moving from its former spot on Hocking Street to the corner of West Washington Street and Cables Alley, the Nelsonville Post Office served 11,400 customers between city delivery, rural delivery, general delivery, and rented boxes. (Courtesy of NPL.)

To make way for the new building, several old buildings that were originally located on the West Washington Street lot had to be razed. The Myers House owned by Hezekiah H. Myer, a coach station, and the Ashton House built in 1840 to store wool and also rumored to have been an opera house, were razed along with the Cooley Building, originally built in 1870 by Gideon L. Cooley. (Courtesy of NPL.)

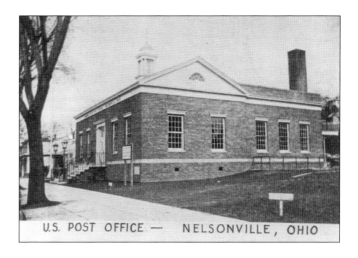

U.S. POST OFFICE — NELSONVILLE, OHIO

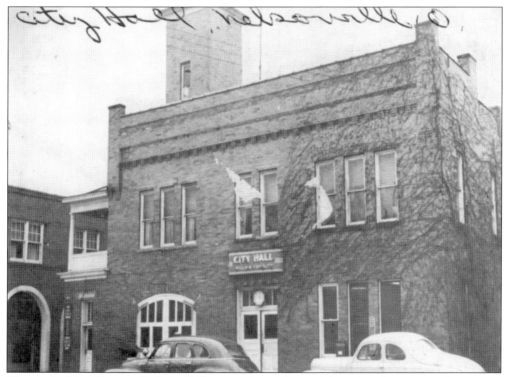

The city hall building was built in 1901; at one time, it housed the police department, fire station, mayor's office, and water department. It also housed any prisoners that had been taken in. Today the old city hall is owned by Rocky brands and is home to some of its company offices. The building has been restored and looks very much like it did in the early 1900s. (Courtesy of ACHS&M.)

Here is an interesting photograph of some businessmen from Nelsonville. Clockwise from the bottom left are Winfield Scott (1848–1934); Dave Burnell (1871–1957), a shoe repairman for many years with a store on West Washington Street who also fought in the Spanish-American War; Alfred Scott (1875–1954), son of Winfield Scott; and George Raine (1848–1923). (Courtesy of NPL.)

Alfred Harrison Carnes (1824–1915) came to Nelsonville in 1842 at the age of 17; by 1846, he was fighting in the Spanish-American War. In 1856, he became a store clerk for Matthew Van Wormer, a coal mine operator, and later bought the store located where the Nelsonville Public Library parking lot is now (on the Washington Street side). This photograph was taken at Carnes's daughter's house on East Washington Street when he was in his 90s, one of the last remaining Spanish-American War veterans. (Courtesy of NPL.)

Among old photographs of Nelsonville is this interesting one of what looks like a man and his nine sons. Did they work in a bank or operate a coal mine? Is this just a family portrait? With no names attached, it is hard to determine, but the older man was no doubt either a coal mine owner or prominent businessman of Nelsonville. (Courtesy of NPL.)

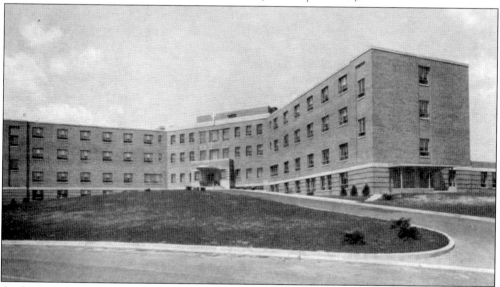

Oral Daugherty, a one-time mayor of Nelsonville, donated the land on the northern edge of Nelsonville for a hospital. On April 17, 1950, Mount Saint Mary's under the Franciscan Sisters of Stella Niagara opened a 100-bed facility. In 1980, the hospital was bought by a Columbus hospital and became Doctors Hospital. (Courtesy of NPL.)

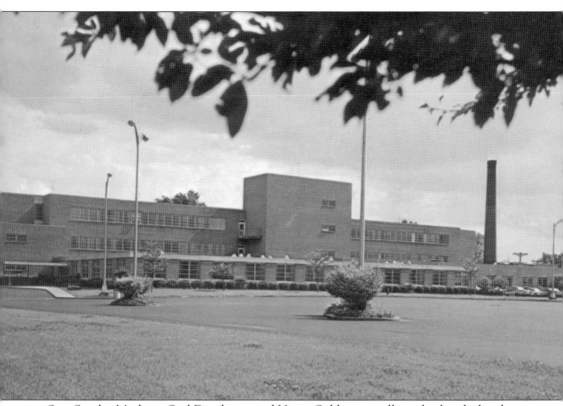

Sen. Stanley Mechem, Oral Daugherty, and Victor Oakley were all involved with the planning and launching of the Southeastern Ohio Tuberculosis Hospital in March 1957. Located just up from Pleasantview Avenue and across the Athens–Hocking County line, the hospital served 14 counties in Ohio and started as a 100-bed facility. As the cases of tuberculosis dwindled, the hospital closed in 1972. From 1973 to 1978, the building was used as a treatment center for mentally handicapped children. In 1983, the building became the Hocking Correctional Facility, which is still there today. (Courtesy of ACHS&M.)

Three

THE PUBLIC SQUARE

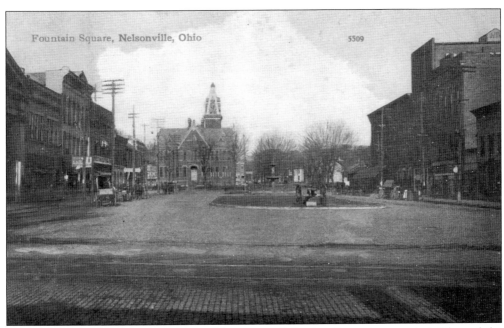

In the foreground of this view of the public square, Columbus Street is paved in bricks and the streetcar rails that went through town are visible. The Civil War cannon sitting on the lawn was later moved to Greenlawn Cemetery to grace the middle of the Soldiers Circle. (Courtesy of Linda Westfall.)

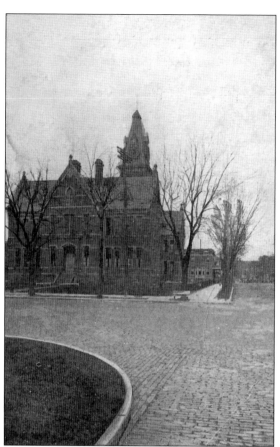

In 1903, the public square was paved in brick. The Central School sits in the background with Fort Street running along the right. The old YMCA can be seen down Fort Street and on the right. (Courtesy of Linda Westfall.)

In the foreground is the Nelsonville Fountain, which was erected in 1904 by the Woman's Temperance Group. The Masonic building in the background was built around 1887 and housed the Masonic lodge upstairs; the bottom floor was home to Parks Drugs. In later years, Stoltz Drugs and Cookson's were in the bottom half. Today, Mama Renies and the Nelsonville Flower Shop reside there. (Courtesy of NPL.)

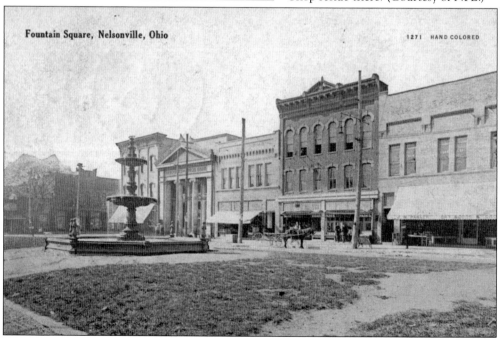

Fountain Square, Nelsonville, Ohio

1271 HAND COLORED

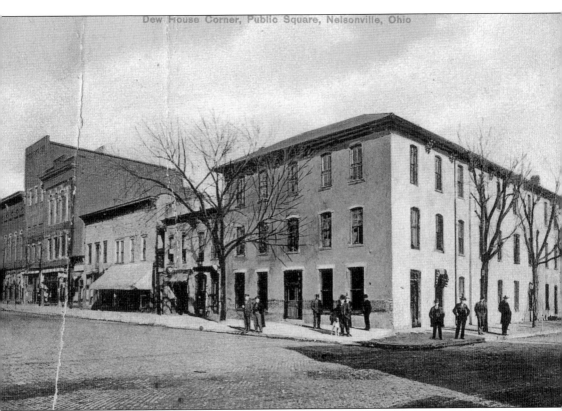

The building on the corner is the famous Dew House, built by Thomas Dew in 1835. Although known as the Dew House today, it originally started out in 1839 as the Ohio House. In 1861, there was a recruitment office on the main floor. A third story was added in 1876, and by 1878 it became known as the Dew House. The first president to visit was William McKinley, due to the mine strikes. In 1910 Warren G. Harding visited, and last but not least, William Howard Taft and Theodore Roosevelt both visited in May 1912 to campaign against each other. (Courtesy of NPL.)

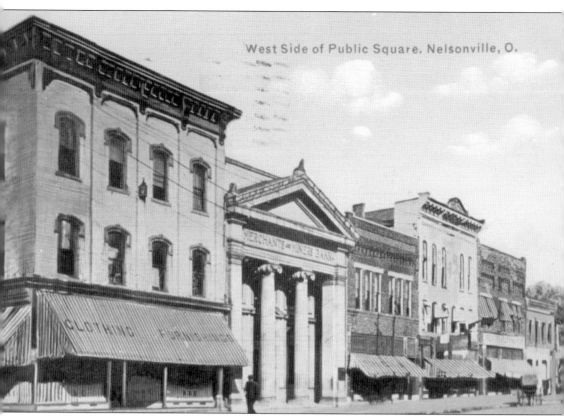

West Side of Public Square. Nelsonville, O.

Built in 1872, the building at far left started out as a general store. By 1904, Aumiller and Edington had a clothing and general-merchandise store that also sold men's furnishings and men's and boys' shoes. Supposedly, this is the lot where town founder Daniel Nelson built his house before it was moved to Fayette Street. From 1911 to 1987, Hoodlets Department Store resided here, selling clothing and school apparel. In 1980, the First National Bank acquired this building. Today it is home to a lawyer's office. (Courtesy of ACHS&M.)

The Merchants and Miners Bank was built in 1905, but before the bank was erected there were several small structures here. From 1887 to 1905, the Sanborn Fire Insurance maps show that there was everything from storage buildings to jewelry stores on this site. After 1914, Citizens Bank owned the building until 1943, when First National Bank bought it. (Courtesy of NPL.)

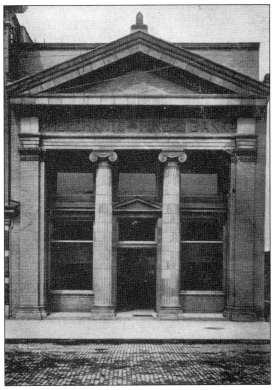

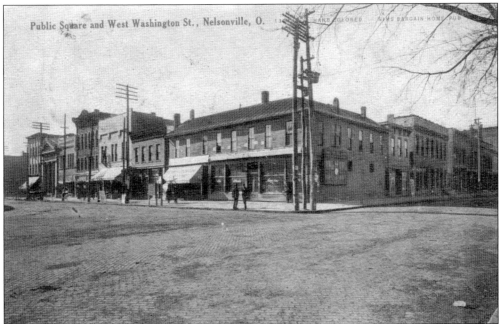

The lot on the corner of Washington Street and the public square was once owned by the Poston family. Levi McDowell, a famous Nelsonville photographer, at one time had his studio on the second floor of this building. Many of his old photographs still survive today; from family photos to school and business groups, McDowell was there to capture the moment. (Courtesy of NPL.)

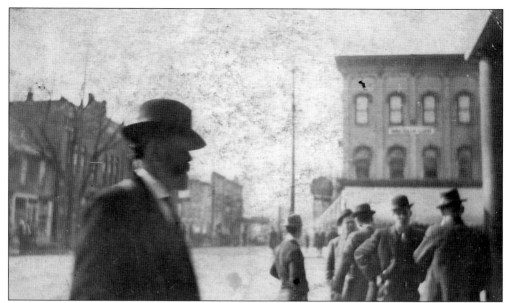

Dr. Samuel Edgar Butt was caught in this snapshot taking a Sunday afternoon stroll across downtown. This photograph was taken in 1915, and Dr. Butt was a well-known physician in the Nelsonville area. His son Charles, who also became a doctor, wrote many a diary about Nelsonville and all its happenings from the late 1890s to the mid-1900s. (Courtesy of Christine Vischer.)

On the final Friday of each month except December, the public square holds a market and art displays in various buildings. During an October Final Friday, the Dew House received this stuffed Teddy Roosevelt in honor of his campaign visit in 1912. From afar it looks as if President Roosevelt is still standing on the porch giving his speech. The history of Nelsonville lives on. (Author's collection.)

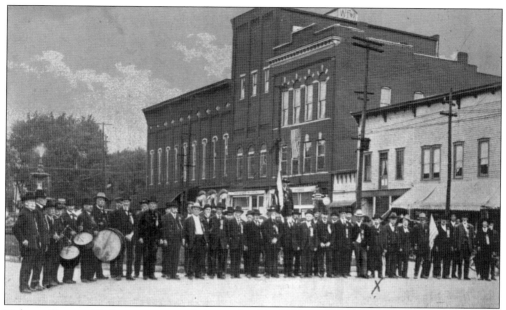

Nelsonville provided many men to fight in the Civil War, and most fought in Company G of the 18th Ohio Volunteer Infantry. Here is a photograph taken in the early 1900s of some of the remaining veterans, also members of the Grand Army of the Republic No. 38. In July 1863, Gen. John Hunt Morgan of the Confederate army rode through, burning canal boats and ransacking local businesses. (Courtesy of Christine Vischer.)

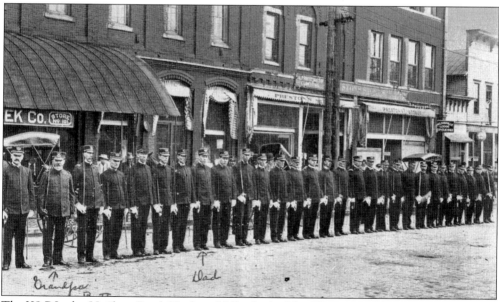

The K&P Lodge Uniform Rank Hocking Valley Lodge No. 75 is pictured lined up along the east side of the public square. The building behind them and to the left was part of Stuart's Opera House and home to the Sunday Creek Company Store at the time. To the right was Lorenzo and Fred Preston's mercantile store. (Courtesy of Christine Vischer.)

Just down the street from the Dew House sits Stuart's Opera House. George Stuart had the opera house built in 1879 after his showboat that traveled the canals sank in 1869. Entertainment for Nelsonville and the surrounding coal towns lasted until 1924, when the coal boom was over. Just as a new life was starting for Stuart's, fire struck in 1980. In 1997, it was opened back up and once again provides entertainment for Southeastern Ohio. (Author's collection.)

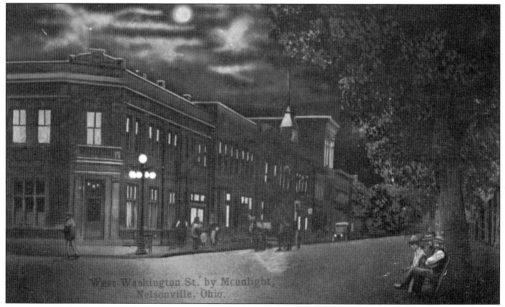

Showing Nelsonville under the moonlight, this postcard view is from the corner of Washington Street and the public square. At right is a bench that sat in front of the old Central School, often referred to as the liar's bench, where the old-timers could sit and share stories of times gone by. (Courtesy of NPL.)

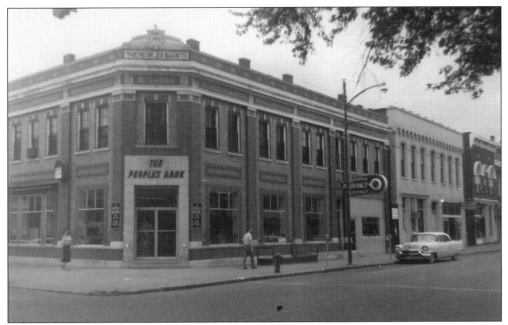

Pictured here is The Peoples Bank on the corner of Washington Street and the public square. This photograph was taken in September 1960 on what looks like a busy workday afternoon. Behind the bank but still part of the building was the Oakley Insurance Agency, and to the right was the Hilleary Shoe store. (Courtesy of NPL.)

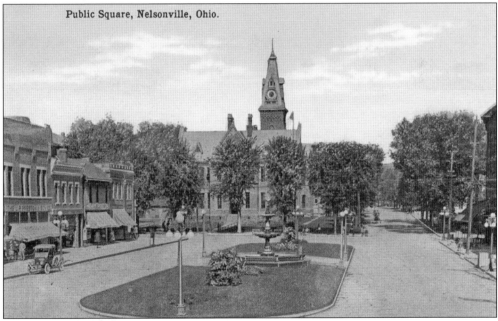

Pictured here after 1910, the public square is missing the Civil War cannon, which had possibly moved to Greenlawn by this time. There is a legend that a pair of alligators were brought up from Florida to live in the fountain. Many times in the spring as a prank, soap has ended up in the bottom pool of the fountain, causing huge bubbles. Pennies are often found where children and adults have made a wish in the old fountain. (Courtesy of NPL.)

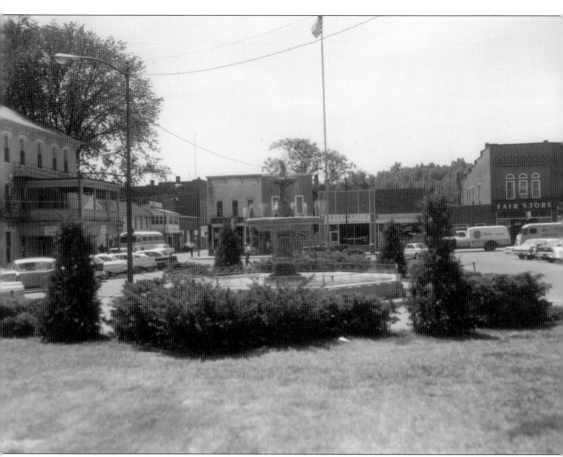

Not much changed on the public square from the early 1900s to the 1960s except for the horse and buggies and Model Ts, which were replaced by more modern automobiles. The Dew House can be seen here at far left. The square was a bustling place in the 1950s, with many stores and restaurants to visit. (Courtesy of NPL.)

Four

TRAINS

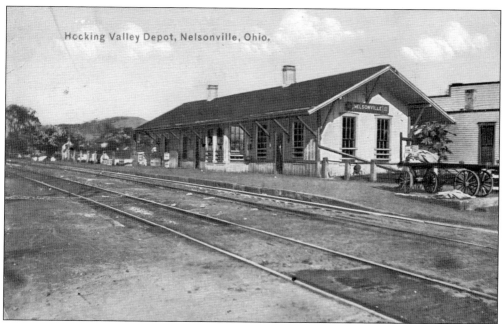

Hocking Valley Depot, Nelsonville, Ohio,

In 1865, the local railway went by the name of the Mineral Railroad Company. The name changed to the Columbus and Hocking Valley by the time the railroad reached Nelsonville in 1869. By 1899, it became the Hocking Valley Railroad; later, it was absorbed by the Chesapeake and Ohio and became part of the Hocking Valley Division by 1930. The Hocking Valley hauled the most coal in Ohio. (Courtesy of NPL.)

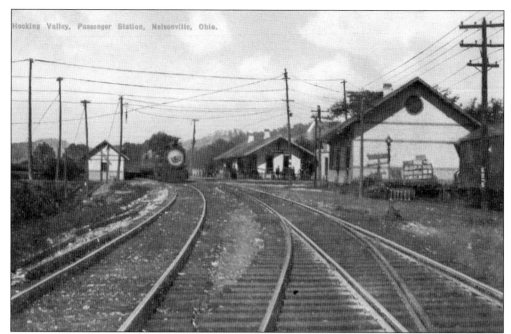

The Hocking Valley passenger station was originally built in 1884 and was retired in 1958. There was also a freight station from 1896 to 1965. The railroad reached Nelsonville on September 17, 1869, and by 1880, the population of Nelsonville had reached over 4,000 people due to the coal industry. The railroad provided a much-needed way to transport coal that was cheaper and more effective than the canals. (Courtesy of NPL.)

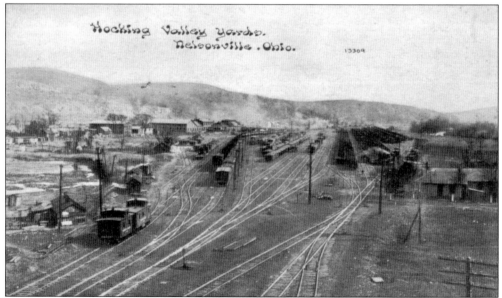

The Nelsonville train yard had 33 designated classified tracks. The section on the left was known as the "heavy side," consisting of 23 tracks, and took in the inbound coal loads. The right side was referred to as the "light side," consisting of the other 10 tracks, where the empty cars were handled. At one time, the train yard topped out at 52 crews. Between 1915 and 1938, over 57 million tons of coal passed through the Nelsonville train yard. (Courtesy of NPL.)

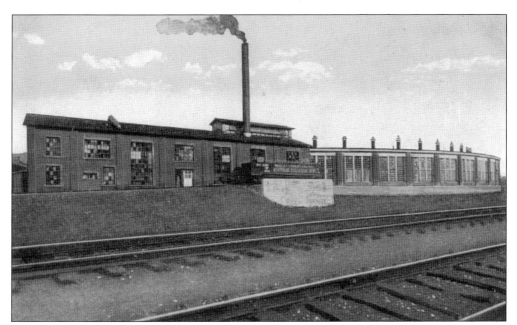

The first roundhouse started out with only five stalls, but as the coal industry boomed it was expanded to 10 stalls. Not far from the old roundhouse was a 300-ton coal tower built in 1917 and torn down in 2010. The roundhouse burned down in the 1990s. (Courtesy of NPL.)

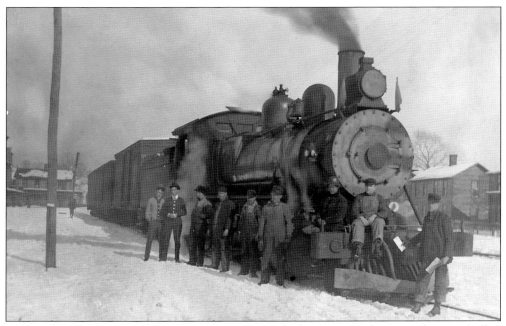

The Hocking Valley Railroad employed many during the boom years. There was also a yard office near Railroad Street and the old city park; it was built in 1920 and closed down in 1967 and housed the telegraph office, freight agent, and store clerks. The men in this photograph could probably tell many stories of the old railroad days and all the steam engines that passed through. (Courtesy of NPL.)

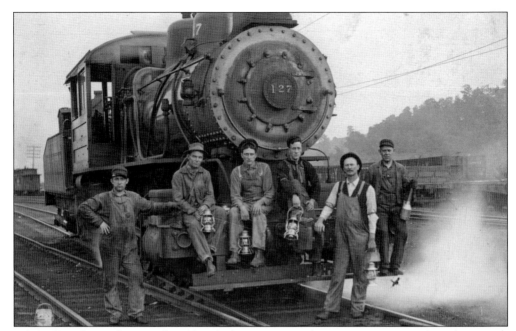

After a long day working on the railroad, these men are taking time out to pose for a photograph with steam locomotive No. 127. The man at far right is identified as Cassius Cash Cummins (1877–1923), an engineer with the Hocking Valley Railroad. On October 6, 1923, after putting his engine away, Cummins fell on the tracks and broke his kneecap; he later died, not from his fall, but from complications due to pneumonia. (Courtesy of Christine Vischer.)

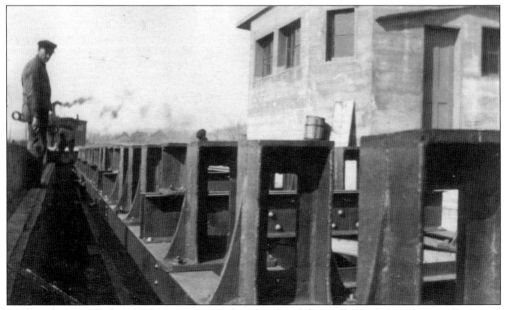

In this photograph from 1921, men are working at the Nelsonville Rail Foundation. (Courtesy of ACHS.)

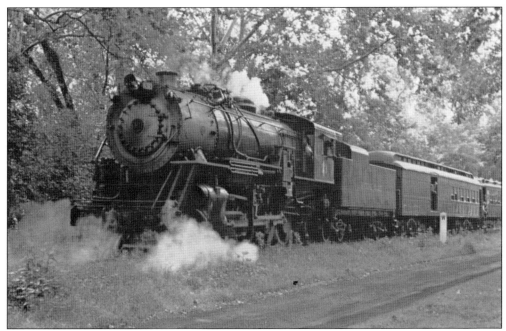

Today, the Hocking Valley Railroad has become the Hocking Valley Scenic Railway. It no longer hauls coal, but rather tourists wanting to go back in time to find out what it was like to ride a passenger train through the Hocking Valley. With Santa Trains, Fall Foliage, the Great Train Robbery, and Wine and Cheese Trains, there is something for everyone. (Courtesy of NPL.)

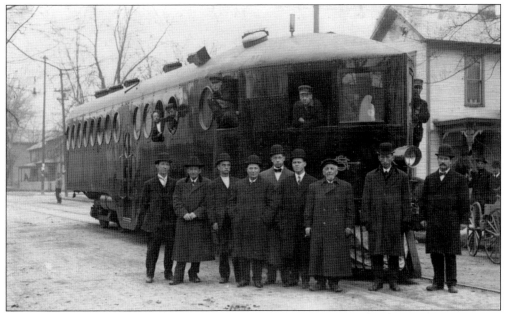

Pictured here in 1910 are the men who helped bring the Hocking–Sunday Creek Traction Company streetcar to Nelsonville. Standing from left to right are Charley Vorhes, Gaston Coe, Marcellus Krieg, Ed Shafer, the unidentified train manufacturer representative from Nebraska, Warren Badger, Col. Charles P. Tutt (promoter), Ed Young, and Hud Price. Jim Beard is leaning out of the front window of the streetcar. (Courtesy of NPL.)

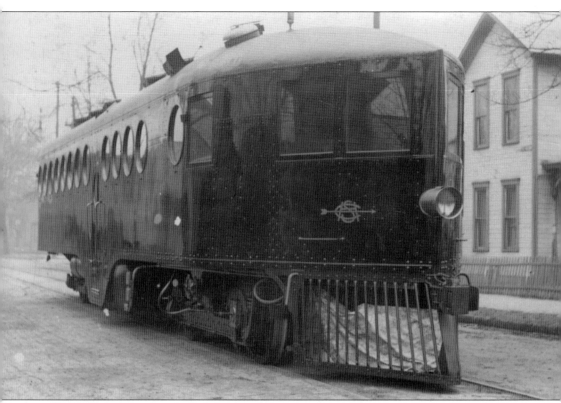

The Hocking–Sunday Creek Traction Company was incorporated on July 10, 1909. The first trip was on February 10, 1910, with a run from Nelsonville to Myers Crossing (the area near Greenlawn Cemetery in Doanville). The line ran along Columbus Street, down Fulton Street across where the Baird lot was (now the city park), and down Fayette Street to Chestnut Street. (Courtesy of NPL.)

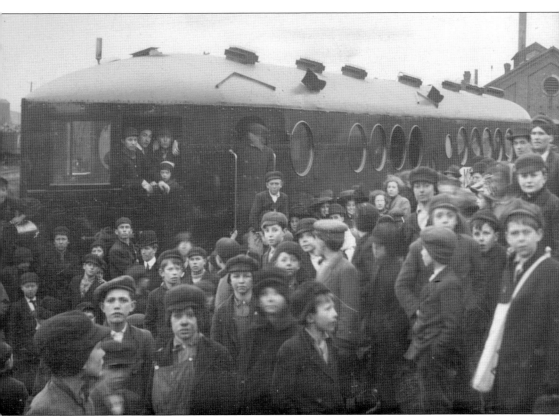

A very excited group gathered to see the Hocking–Sunday Creek streetcar arrive in Nelsonville. The car was a McKeen purchased from the Union Pacific Railroad in Omaha, Nebraska. This photograph is possibly from the first day it arrived in Nelsonville. According to an *Athens Messenger* article, Baker Young, a young boy of only eight, said that he rode with his father, Edison Young, all the way from Omaha, Nebraska, to Nelsonville on the day they brought the traction car home. He might be the young boy inside the car. Courtesy of ACHS&M

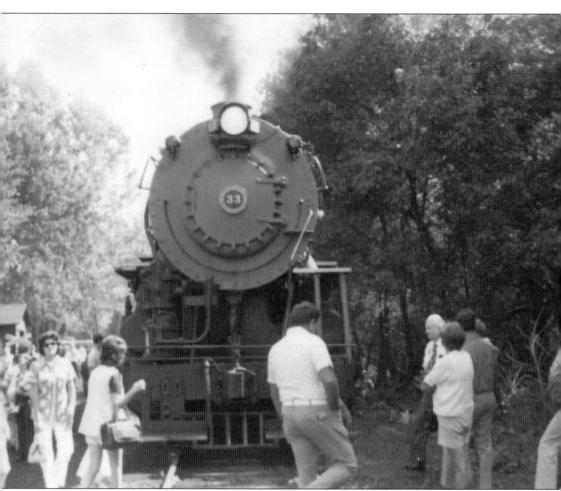

This photograph of the Hocking Valley Railroad from 1973 shows tourists boarding for a scenic weekend tour. After the bustling railroad boom, the Hocking Valley Railroad turned to weekend tours of the valley to keep the steam engines running. (Courtesy of Linda Westfall.)

Five

FLOODS AND FIRES

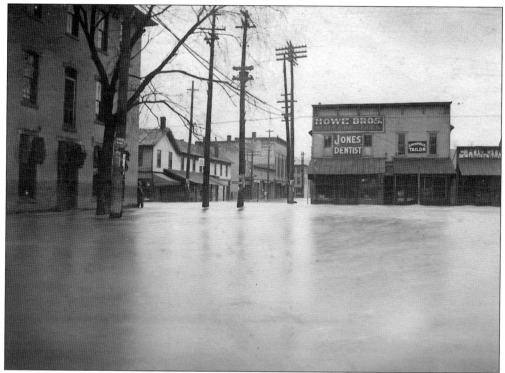

During the flood of March 1907, the water reached all the way to the public square. At far left is the Dew House—it is hard to believe the Hocking River could reach so far. Not much damage was done on the square other than lots of debris left behind to clean up after the waters subsided. (Courtesy of NPL.)

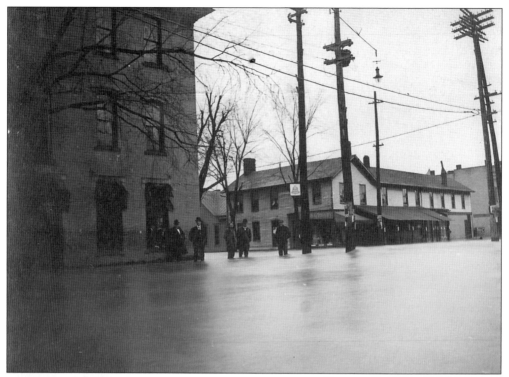

Here is another angle of the 1907 flood. The Dew House is on the left again, and at center is Evans Grocery with the front facing Columbus Street and extending down Hocking Street. At the end of Hocking Street was the Hocking Canal basin. (Courtesy of NPL.)

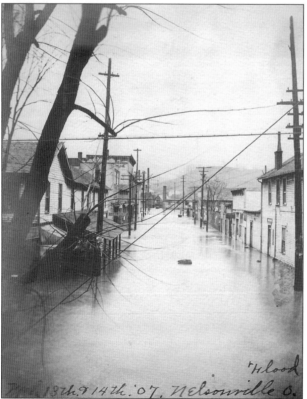

In this view of Hocking Street, it looks like a barrel is floating down the street. None of these old buildings are standing today, and the street looks entirely different. At the end of Hocking Street was part of the Hocking Canal, which later became Route 33 through town. The Rocky outlet store is located where the stacks are, at center in the distance. (Courtesy of NPL.)

60

It looked like a river running through town. This is the corner of the Aumiller and Edington clothing store on Columbus Street. Taking a closer look, a group of people have gathered to watch the floodwaters. It must have been scary to see all of this water surrounding the town. Only the upper streets, such as Fort, Jefferson, and Franklin were unaffected. (Courtesy of NPL.)

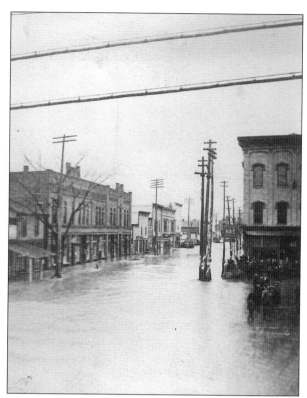

This photograph was taken from a rooftop by someone adventurous. The view looks over the Columbus Street businesses and past Baird's lot behind the store buildings to the train tracks. In the far distance is Robbins Road, which crossed the river and is now called Hocking Parkway. (Courtesy of NPL.)

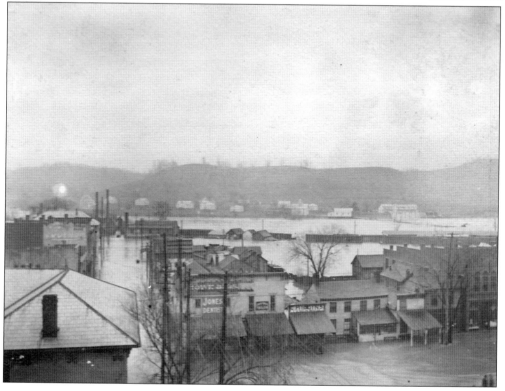

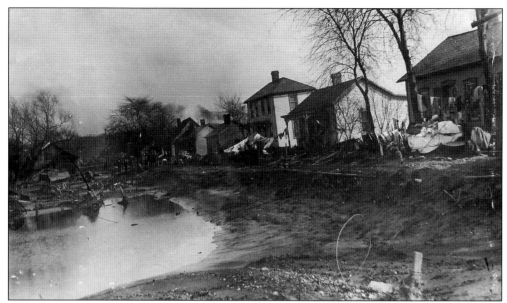

Here, destruction along the towpath can be seen. The flood of 1873 washed out the canal below Nelsonville, and the flood of 1884 destroyed it above Nelsonville. By the time the 1907 flood came through, not much was left. One man claimed he built a whole house out of the driftwood left from the flood. (Courtesy of NPL.)

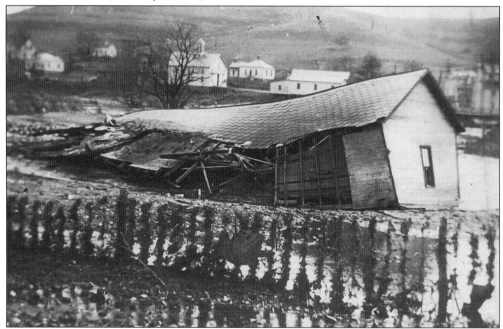

There were three fatalities in Nelsonville during the 1907 flood. Mary Jane (Lush) Marsh (1851–1907) and her son Louis John Marsh (1878–1907) were stranded on the rooftop of their house when it got swept up in the flood and crashed into the train station. Harry Low(e) attempted to save both her and her son until his boat capsized and all three drowned. According to the news article, Harry Low(e) had not been found at the time. It is unknown if this is the house, but many were damaged or pulled into the floodwaters. (Courtesy of NPL.)

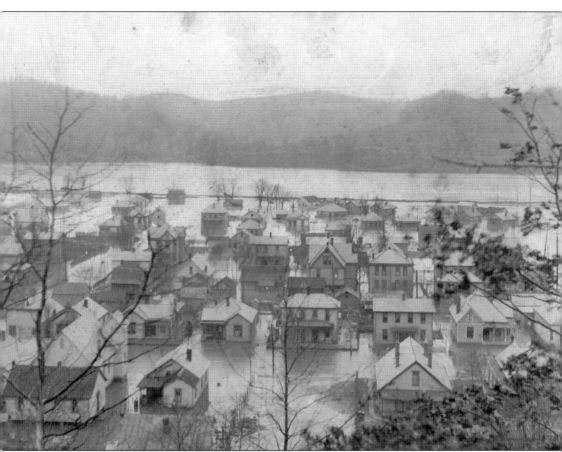

Here is a bird's-eye view of the east end of Nelsonville covered in floodwater. This photograph was taken from High Street looking down onto Walnut, Chestnut, and beyond. Many of these homes are still standing. It is hard to see just where the Hocking River began; in this photograph, it had filled the valley. In the background the water can be seen reaching practically to the rooftops. (Courtesy of NPL.)

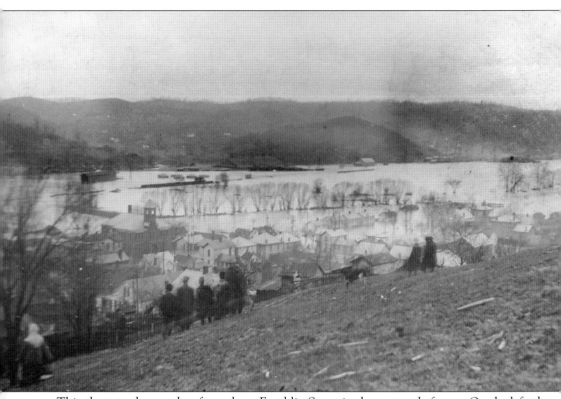

This photograph was taken from above Franklin Street in the west end of town. On the left, the building with the steeple is the old West End School. The line of trees in the background shows were the Hocking River would be when not out of its banks. East Clayton, where the brick kilns were located, is also in view. (Courtesy of NPL.)

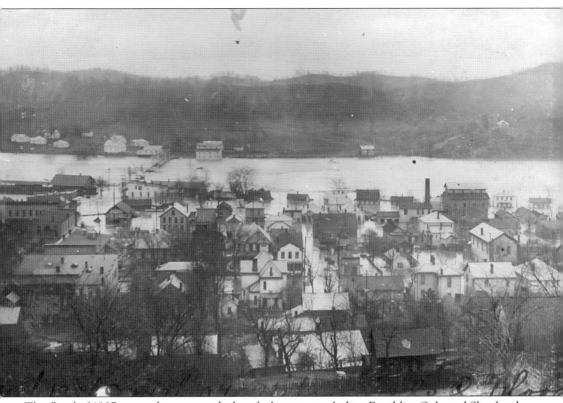

The flood of 1907 covered pretty much the whole town, excluding Franklin, Oak, and Shepherd Streets. This photograph looks down onto Franklin Street, West Washington Street, and beyond to West Columbus Street. On the right in the distance, Freer's Mill can be seen. On the left is the bridge that crossed over by Robbins Mill. (Courtesy of NPL.)

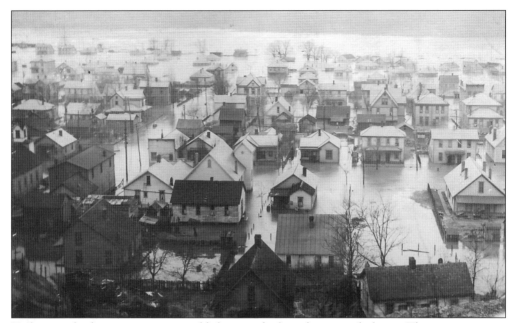

Unfortunately, there are not as many old photographs from the east end of town. This image captures many houses that are still standing today. The streets of Walnut, Poplar, and Canal were inundated by springtime rains that caused the levee about a mile away to burst. (Courtesy of NPL.)

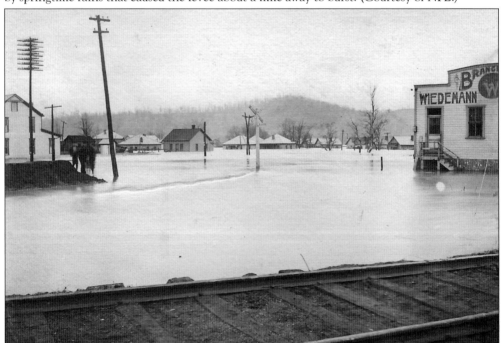

The location of this photograph is believed to be near where the train station was in 1907. Mary Marsh's family home crashed into the station, and it is said that the water was moving at around seven miles per hour when the levee broke. Many families had to scramble to their rooftops to escape floating away. In later years, the area was sandbagged to prevent floodwaters from moving into town. (Courtesy of NPL.)

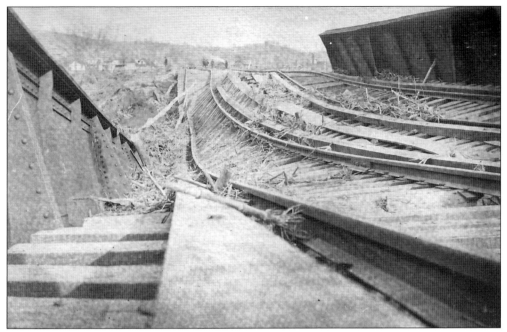

The train tracks suffered quite a bit of damage in March 1907. One Nelsonville businessman left on a trip to Lancaster right before the major flooding began, and it took him over five hours to reach his destination. Normally, even with several stops, it only took one and a half hours. After the flooding, it took around 10 days to get the tracks fixed and trains back on schedule. (Courtesy of NPL.)

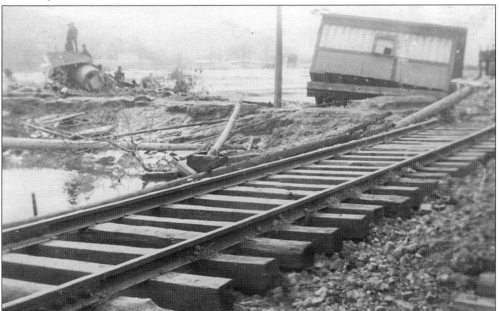

Many houses and buildings were swept up in the flood. Due to a huge growth in population, many homes were constructed quickly on Myers and Jackson Streets, not giving a thought to what a flood would do to them. Many families were stranded on rooftops until help could come. It was said that over two thirds of Nelsonville was flooded. (Courtesy of NPL.)

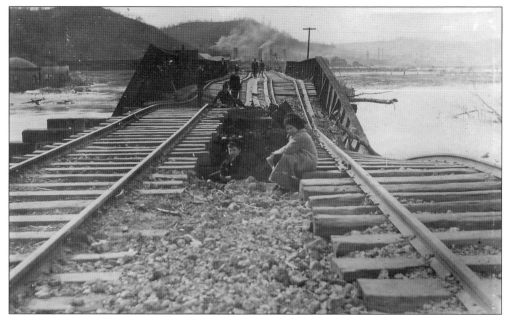

Dr. Cassius G. Dew, the mayor at the time, proposed dynamiting the Black Bridge in order to release debris that had accumulated underneath. Mayor Dew was acting on behalf of the Nelsonville citizens, but the Hocking Valley Railroad was not happy about his decision. In the background of this photograph, the Nelsonville brick kilns can be seen; they also were surrounded by the floodwaters, and only their rooftops and stacks are visible. (Courtesy of NPL.)

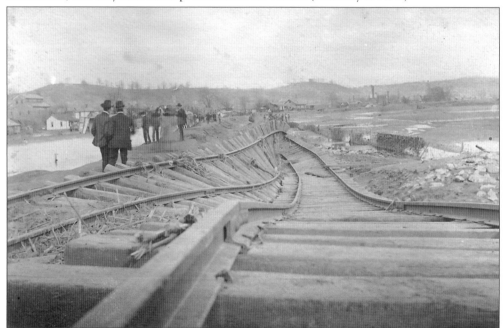

It was said that when the levee broke, it sounded like Niagara Falls was rushing through town. When the railroad tracks got washed together, they began to look like a picket fence. The section from the depot to the North Bridge was washed out, and it took the railway men 10 days to get them fixed and trains running again. (Courtesy of NPL.)

From this photograph found among the flood of 1907 images, it looks like these men found a nice dry spot. Taken across the river on Robbins Road, Nelsonville can be seen in the background. It looks like these unidentified friends were very happy to have survived the spring rains. (Courtesy of NPL.)

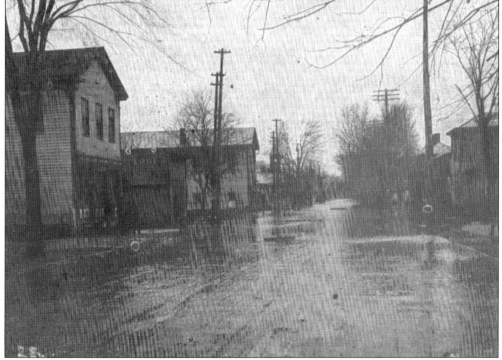

This photograph came from a postcard booklet that was produced by the local newspaper on the 1907 flood. When the levee broke, water rushed quickly down West Washington Street. The third building on the left was the IOOF Lodge. Most of the homes on the right are still standing. Any homes built on this street after 1907 were built up to escape another flood reaching their basements or main floors. (Courtesy of NPL.)

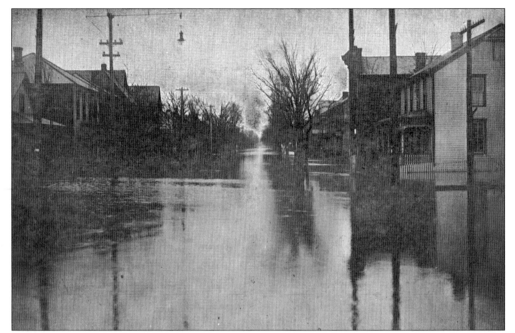

This is a rare view of Chestnut Street in the east end of Nelsonville. The floodwater had already fallen about 18 to 24 inches when this photograph was taken from the railroad tracks that cross the west end of Chestnut Street. Many years ago, there were several sets of tracks that ran back into the hollows to collect coal to be shipped out. (Courtesy of NPL.)

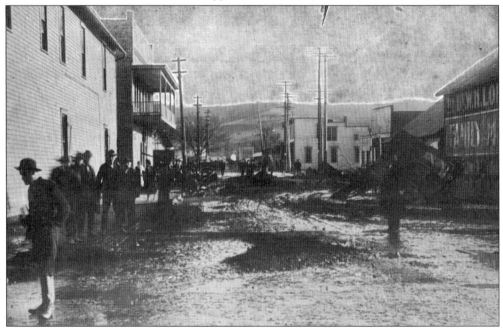

Fulton Street was littered with dead livestock when the waters receded. Many families in town still owned chickens and cows, and the water rose so quickly that many animals drowned. Some saw animals floating down the street that drowned before they could save them. It would seem strange to see so many animals in town today. (Courtesy of NPL.)

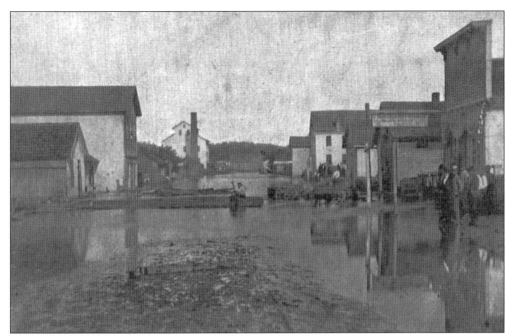

The March 1907 flood was not the first to wreak havoc on Nelsonville. On July 3–4, 1873, the water rose up to Columbus Street. In this photograph are the old Shively house (left) and the Swackhammer Building (right) later known as the Coxey House. Nelsonville had several boardinghouses for miners to stay in. (Courtesy of NPL.)

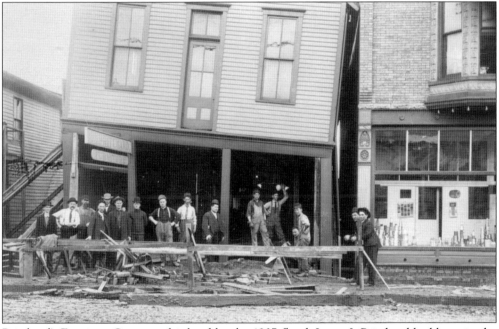

Pritchard's Furniture Store was hit hard by the 1907 flood. James I. Pritchard had been in the furniture business for many years at the time of his death in 1942. His store ran from 1895 to 1935, when he sold out to the Allen brothers. It is possible that he is the man standing at center in the suit and hat taking in the damage to his store. (Courtesy of NPL.)

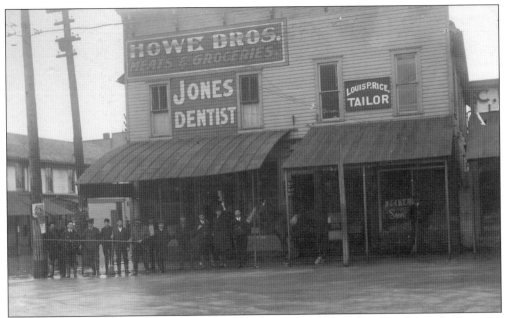

Situated on the corner of Hocking and Columbus Streets was Howe Brothers Meats & Groceries and the offices of Jones the dentist and Louis P. Price the tailor. A group of men are standing on the corner; one has what might be some sort of measuring stick. Under the canopy is a horse standing among the group of men. Some livestock were not as lucky as this horse. This corner is now home to the Nelsonville cable office. (Courtesy of NPL.)

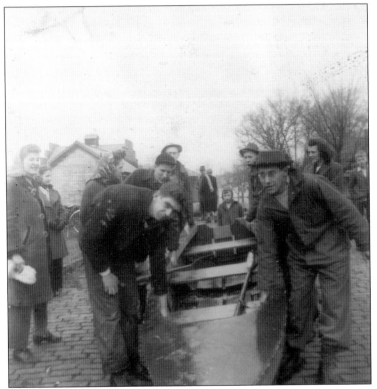

In March 1945, another flood hit the town. This group of young men and women were well prepared, and are seen here ready to launch their boat. The girl at left center with a scarf is Anna Bateman. This flood was not as devastating as the 1907 and 1913 ones; in fact, it is hard to find any information on it now. (Courtesy of Kory Gulley de Oliveira.)

These two girls were hanging out during the 1945 flood. It is unknown where the restaurant that sold "Fresh Fish, Oysters, and Potatoes" was, but the girl on the right is Wanda Bateman. (Courtesy of Kory Gulley de Oliveira.)

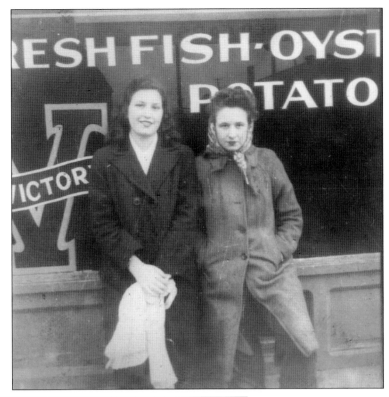

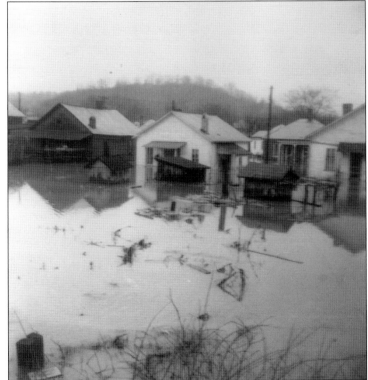

The flood of 1945 crept up onto the streets of Nelsonville again. This photograph is possibly from the Myers Street area, one of the first places to flood along with the old city park when floodwaters hit. (Courtesy of Kory Gulley de Oliveira.)

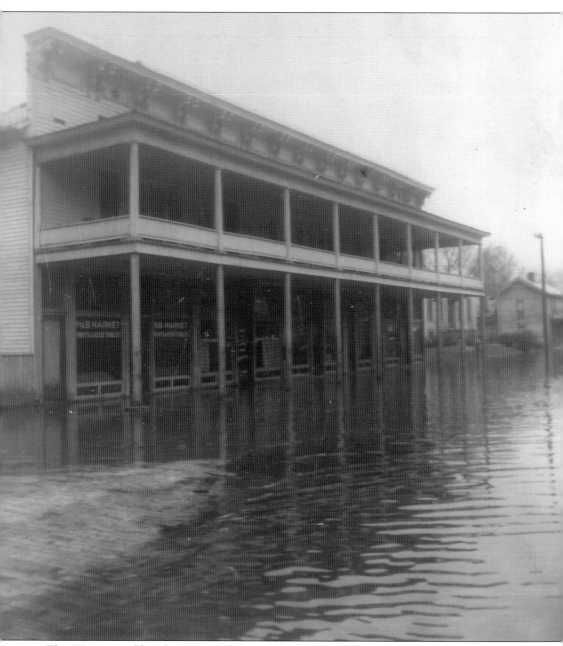

The Warner Building has survived several floods: 1907, 1913, and this one, the 1945 flood. Built in 1890, the original proprietor of the building was Isaac Warner. It was also known as the Smith House. On February 19, 1974, the old Warner Building went up in flames. It was located on the corner of Columbus and Fulton Streets. In the 1980s, a fast-food restaurant by the name of Yankee Burger was on this corner until it became the site of Citizens Bank. (Courtesy of Kory Gulley de Oliveira.)

This is another view of the 1945 flood. (Courtesy of NPL.)

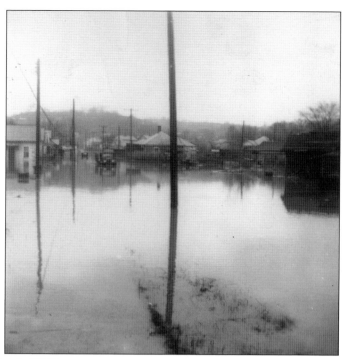

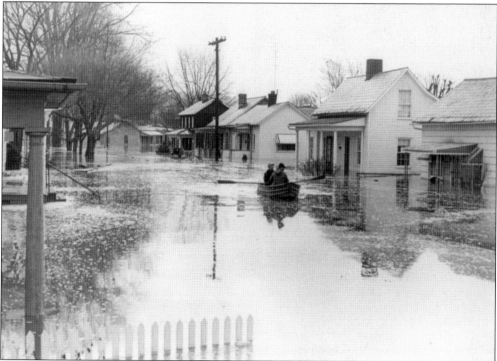

This photograph of the flood of 1964 shows people floating down Myers Street in a rowboat. By the 1960s, the town had started to sandbag to keep the water at bay. Myers and Jackson Streets were always hit the hardest. Many of these houses are still standing and probably have many tales within their walls regarding over 100 years of flooding. (Courtesy of NPL.)

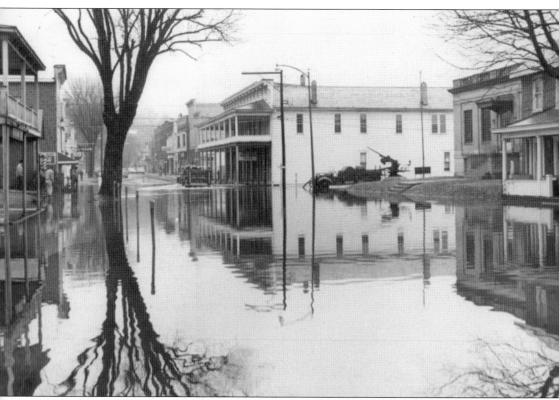

This is a view of West Columbus Street looking toward the public square during the 1964 flood. Many of the buildings on the left are now parking lots; the second one down is now part of the Nelsonville Public Library parking lot. On the right, the building with the military equipment out front is the American Legion, built in 1924, and on the corner of Fulton and West Washington Streets (the big white building with a porch) was the Warner Building, which burned down in the 1970s. (Courtesy of NPL.)

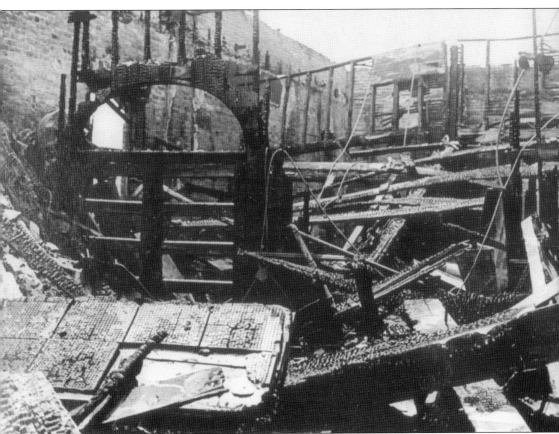

Before the fire, the Elks lodge was located on the corner of Hocking and Fayette Streets. On June 24, 1969, the Elks lodge, located in the Nelson and Patton Building, burned down. This photograph is from the interior of the building. The Elks lodge is now located just across the street, and the old location is now a parking lot. (Courtesy of ACHS&M.)

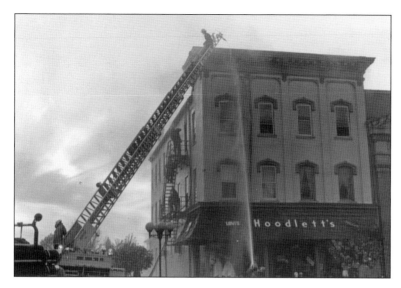

Hoodlett's store on the corner of Columbus Street and the public square had a fire on the night of April 12, 1986. Not much damage was caused, as the fire started in one of the upstairs apartments. Hoodlett's had occupied the building for many years. (Courtesy of NPL.)

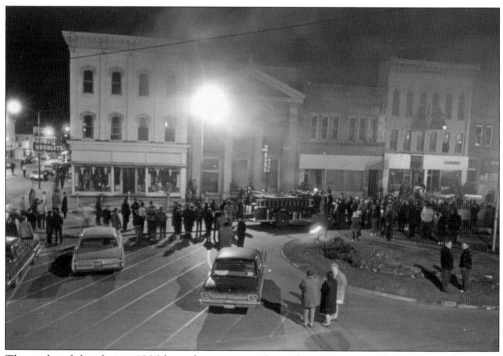

The night of this fire in 1986 brought out many from the town to watch. Reminiscent of the Stuart's Opera House fire in 1980, the residents were fearful when another main building on the public square saw flames. The crowd looks more like they are watching a scene from a movie. In 1985, Hoodlett's was featured in the movie *Mischief* as the Brubaker department store. (Courtesy of NPL.)

During and after the 1980 fire, firemen were able to save many of the library books. In the Local History Department there are still some old papers and books that survived the fire; they are a little charred around the edges but still legible. After the fire, the Nelsonville Public Library moved into the old Fred Beasley Garage at 95 West Washington Street. (Courtesy of NPL.)

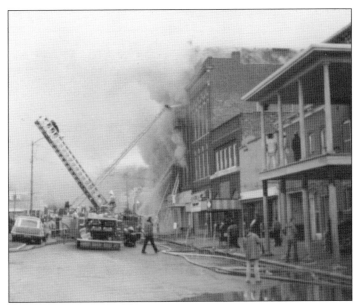

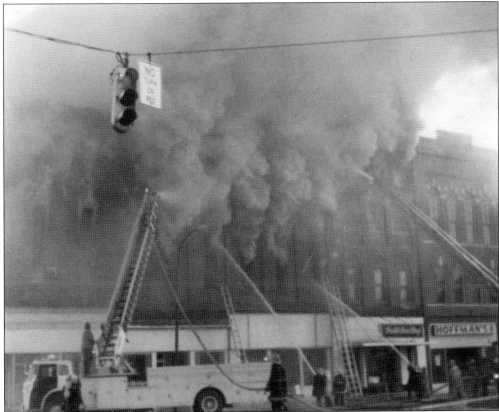

In March 1980, a fire broke out in Stuart's Opera House. This fire destroyed many businesses in this block. The Nelsonville Public Library occupied the bottom part of the opera house. There was also an ice cream parlor under the opera house. The town was extremely lucky on this early spring day, as one of the major buildings in Nelsonville history was saved. (Courtesy of NPL.)

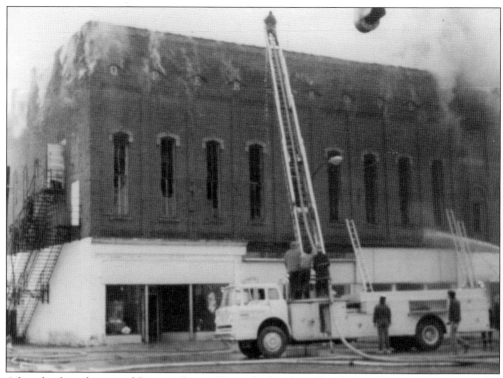

After the fire, the top of Stuart's Opera House had to be refinished with a new layer of bricks. It is barely noticeable today. Inside the building, the fire destroyed some of the old posters on the walls. Today when taking a backstage tour, the guides point out some of the old posters and advertisements that were able to be preserved. (Courtesy of NPL.)

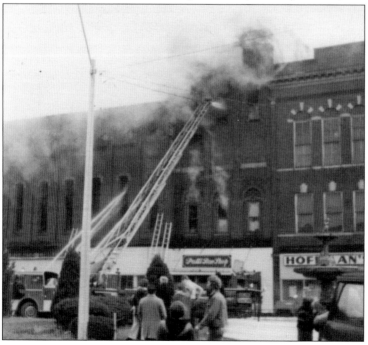

When Stuart's Opera House caught on fire in March 1980, it was in the process of being remodeled. The original chairs from upstairs had been removed and sent away to be restored at the time. Some of the businesses on the first level were the Patti Rae Shop, the Nelsonville Public Library, and an ice cream parlor in the 1879 Room. (Courtesy of NPL.)

Six

CITY STREETS
AND BIRD'S-EYE VIEWS

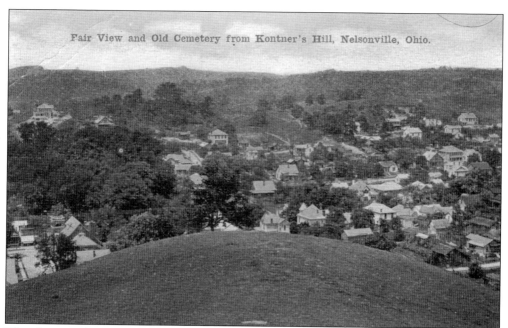

Fair View and Old Cemetery from Kontner's Hill, Nelsonville, Ohio.

This photograph was taken from the top of Kontner's Hill, named after the Kontner family, who owned property in this area. On the left are Short Street and the First Christian Church. Off in the distance on the left is a group of trees shading Fort Street Cemetery. Legend has it that in the late 1800s to early 1900s, there was a "pest house" on Kontner's Hill that was used to quarantine those suffering from smallpox and other contagious diseases. A natural spring called Indian Springs by locals is also located on the hillside. (Author's collection.)

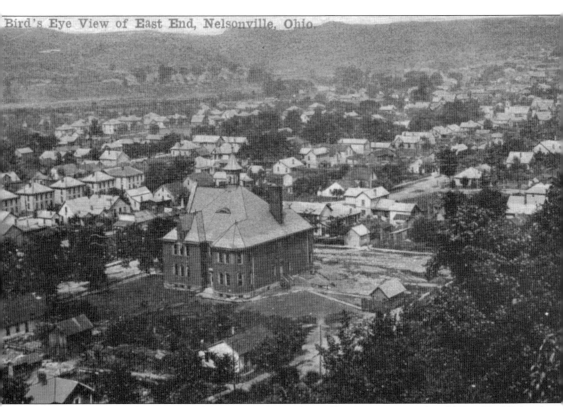

This is a rare bird's-eye view of the east end of Nelsonville. At center sits the old East End School on the corner of Second and Walnut Streets. The four houses on the left of the school that are all identical were referred to as Cables Row. As with any old town, many of the streets and areas had nicknames that had been given by the old-timers and previous owners. The old school was torn down in 1959 and is now the site of several houses. If it were not for this old photograph, no one would be able to tell that this structure ever existed. (Courtesy of NPL.)

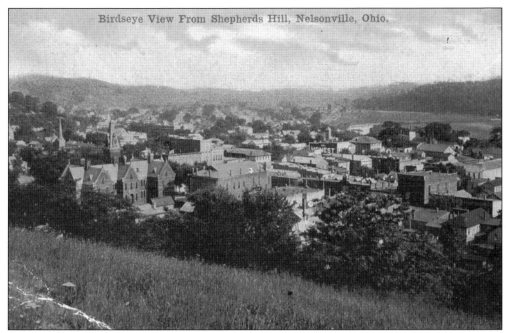

Looking from up behind Franklin Street and Fort Street Cemetery, the valley stretches as far as the eye can see. On the left is the old Central School, and to the right of the school is the back of the Knights of the Pythias building. Across the street at center, Stuart's Opera House and the Dew House can be seen. (Courtesy of NPL.)

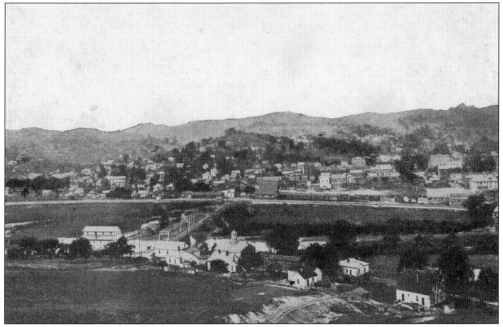

On the left side of this photograph from the late 1870s is the old bridge by Robbins Mill. Many of the houses in the foreground, which date back to the 1850s, are still standing and have been renovated. Across the river, the Hocking Valley Railroad can be seen along with possibly parts of the canal. (Courtesy of NPL.)

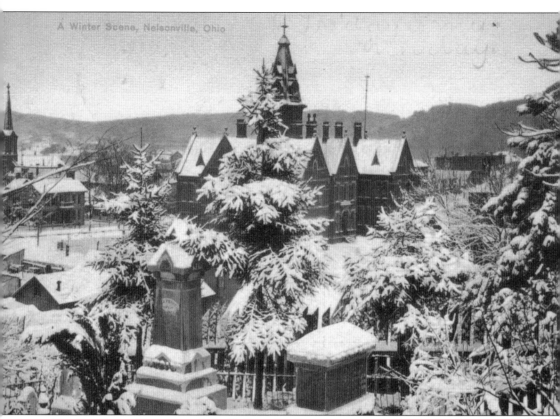

A Winter Scene, Nelsonville, Ohio

The Fort Street Cemetery is full of hills and valleys; many spots are great for photographs since it is high enough to see all over town. Laid out as the first town cemetery, many of Nelsonville's pioneers rest here. Daniel Nelson was among the first to be buried in Fort Street. Several hundred people have been laid to rest here, but not all were recorded. Some folks started out here but were later dug up and moved to the new cemetery, Greenlawn, that opened up in the 1890s just below town. It is said that one of the last persons buried here was also the last person to live on a canal boat, in the 1890s. This is not quite true, because one of the last burials was in the 1950s. (Courtesy of NPL.)

Built in 1905, the Knights of Pythias building has not only served as a meeting hall for various groups but also, the bottom part has held various stores over the years, from doctors' offices to several different drugstores including the Gem Pharmacy and Fosters Drugs, just to name two. Currently, it is home to a very popular quilting shop. (Courtesy of NPL.)

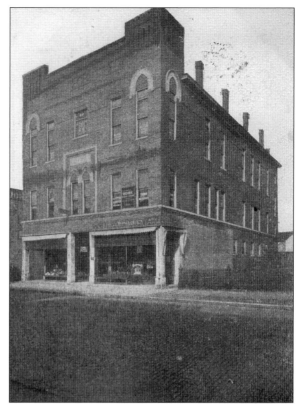

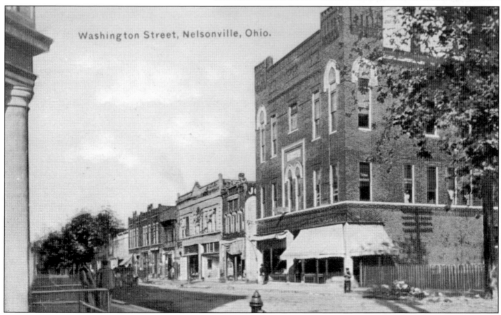

West Washington Street is pictured here from the public square. The first building on the right is the Knights of the Pythias building, constructed in 1905. The third building down was once known as the Buckeye Block and housed the local newspaper until it burned down. Today it is a parking lot for apartments located above the other store buildings. (Courtesy of NPL.)

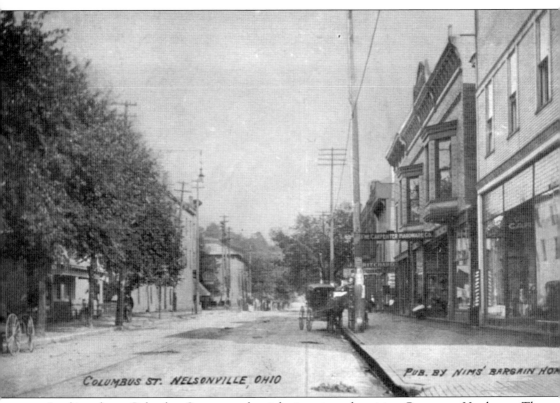

COLUMBUS ST. NELSONVILLE, OHIO

PUB. BY NIMS' BARGAIN HOM

Looking down Columbus Street, on the right is a sign advertising Carpenter Hardware. The Carpenter building was built in 1902 of Union Furnace speckled brick. At a length of 100 feet, the main floor was split in two halves; one half contained furniture, and the other contained hardware. The building also had an elevator that went from the basement to the second story. Carpenter Hardware also had stores in Athens and Glouster. The next building down contained Pritchard's Furniture. (Courtesy of NPL.)

These photographs were both taken on East Columbus Street looking toward Jefferson Street. Many of these old homes still look the same today. Notice the old bricks. The main thoroughfares of Nelsonville are primarily Washington and Columbus Streets. Many of the old homes here were built by doctors, bankers, and other highly esteemed professionals. (Both, courtesy of NPL.)

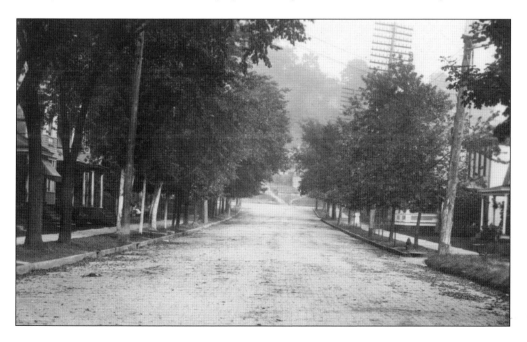

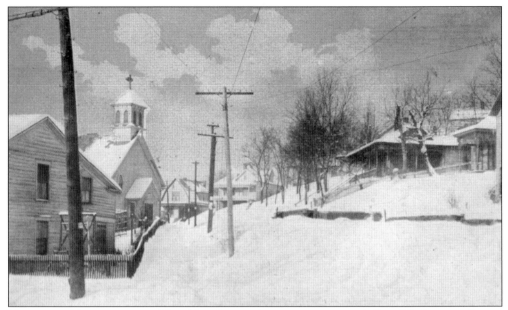

Here is a cold, snowy view of Franklin Street where it meets up with East Washington Street. The first building on the left is the St. Andrews Catholic Church parsonage. No longer there, St. Andrews is just an open grassy spot, and where the parsonage once sat is now the site of a more modern church hall. (Courtesy of NPL.)

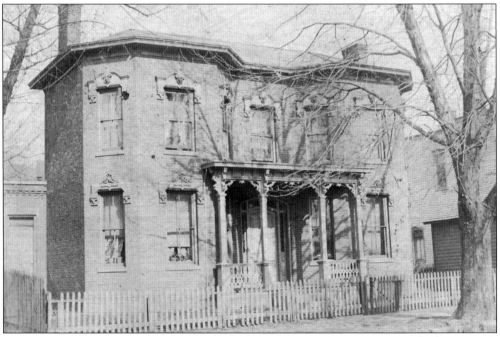

At 152 West Washington Street sits the grand old home of Theatus Ervin Wells (1855–1919). Wells came to Nelsonville in the 1880s and purchased the *Buckeye News*, located on the second floor of the Buckeye building not far from his house on Washington Street. Wells owned and operated this local newspaper for over 20 years. At the time of his death, he was in his third term as mayor. (Courtesy of NPL.)

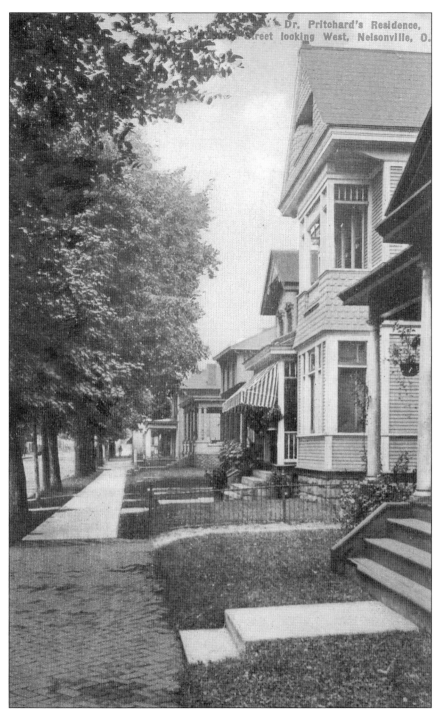

The house at 86 East Columbus Street originally belonged to Dr. Arthur Lee Pritchard. Pritchard (1864–1945) and his family first arrived in Buchtel and later moved to Nelsonville in 1877. Arthur was an 1883 graduate of Nelsonville High School and an 1886 graduate of Ohio Medical College. By 1896, he was known as "the country doctor" and traveled around in his horse and buggy. (Courtesy of NPL.)

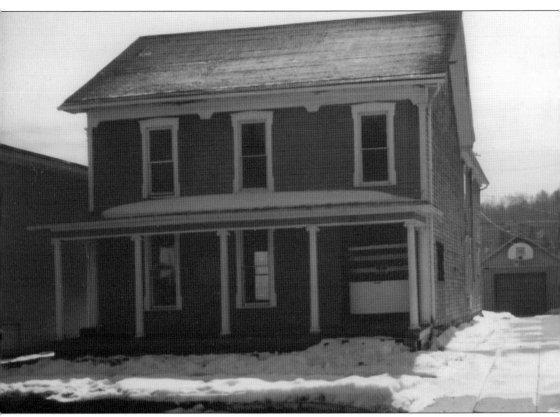

Here is the residence of Nelsonville's first mayor and founder of Cables Hardware (still in existence today in the original building). Charles Cable came to Nelsonville in 1816 with his father and started in the mercantile business; after 1849, the business was passed on to his two sons, Charles A. and Eugene J. Cable. The home on West Washington Street was torn down in the late 1990s or early 2000s. (Author's collection.)

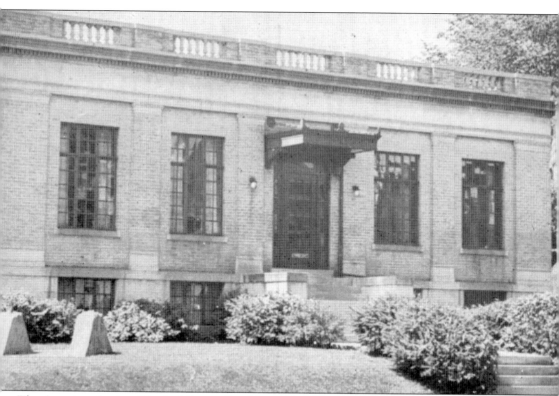

The American Legion Glenford Dugan Post No. 229 was organized in 1919. Built in 1924 at the corner of West Columbus and Fulton Streets, the post was named in honor of Glenford Dugan, who was killed in battle in Belgium during World War I just a few days before the signing of the armistice on November 11, 1918. The first officers of the post were W.S. Rhodes, C.E. Welch, E.S. McCune, and F.R. Jackson (Courtesy of ACHS&M.)

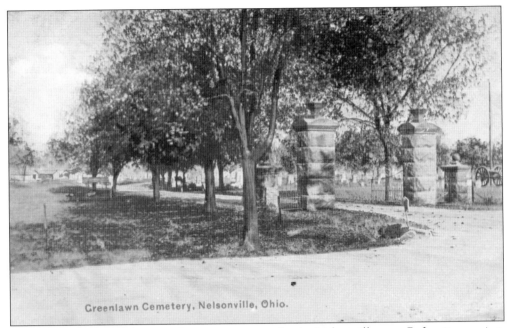

Greenlawn Cemetery, Nelsonville, Ohio.

After 1890, Greenlawn became the main cemetery for the Nelsonville area. Before its opening, the main burial ground was the Fort Street Cemetery, located right in town. In many of the old records, it is not uncommon to find double listings for some people. Many families would have their loved ones moved from the old cemetery to the new so they could all be buried together. It has been rumored that many were moved through town at night. (Courtesy of NPL.)

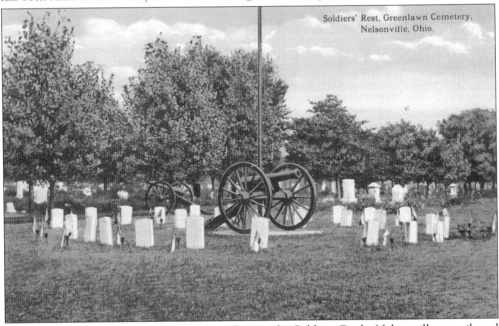

Soldiers' Rest, Greenlawn Cemetery, Nelsonville, Ohio.

On the right side of the entrance into Greenlawn is the Soldiers Circle. Nelsonville contributed many men to fight in the Civil War. The cannon at center originally started on the public square and was later moved to the cemetery. Not all buried in the circle fought with the Ohio regiments; several of the men are from other states but ended up in Nelsonville. (Courtesy of NPL.)

Seven

CHURCH AND SCHOOL

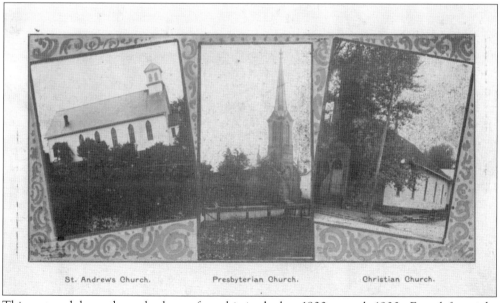

St. Andrews Church. Presbyterian Church. Christian Church.

This postcard shows the early places of worship in the late 1800s or early 1900s. From left to right are St. Andrews Church, located on the corner of West Franklin Street and East Washington Street; the Presbyterian church located on East Washington Street; and the Christian church on the corner of Fort and Short Streets. The Presbyterian church is the only original building that is still standing. (Courtesy of NPL.)

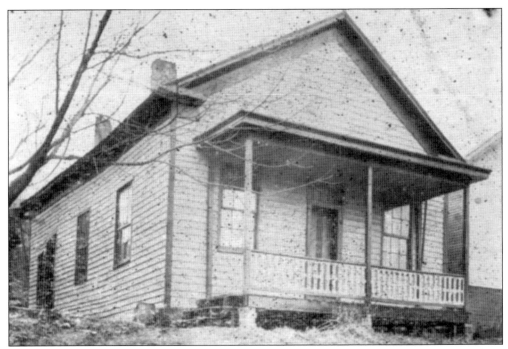

This house was built as a worshiping place for use by those attending the Christian church. It was located on West Franklin Street and was used until 1870, when a new building was erected on Fort Street. (Courtesy of NPL.)

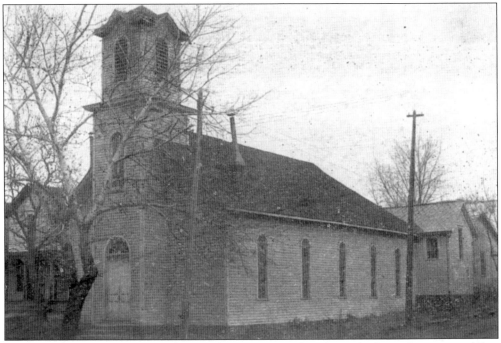

Due to a growing congregation, the Second Christian Church was built on the corner of Fort and Short Streets. This frame building was first started in 1870 and finished by 1873. (Courtesy of NPL.)

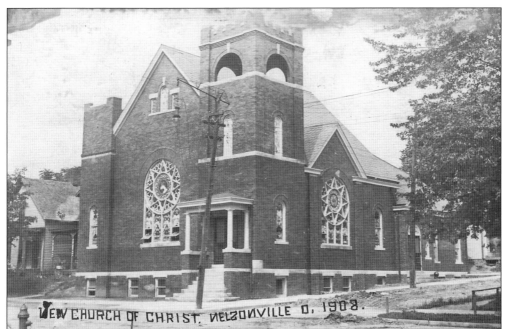

NEW CHURCH OF CHRIST. NELSONVILLE O. 1908.

In 1907, the First Christian Church outgrew their old frame structure that had sat on the lot since 1870 and started laying the foundation in 1907 for a new brick building. In 1913, an addition was built that held an auditorium for the local theater group. (Courtesy of NPL.)

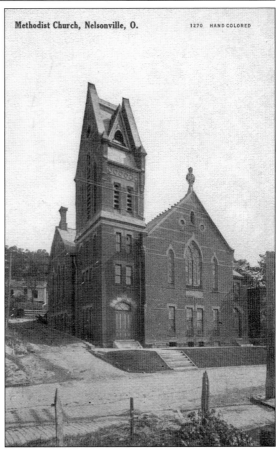

Methodist Church, Nelsonville, O. 1270 HAND COLORED

The Methodist church was one of the earlier congregations to start up, with the first known meeting in 1838. Their first building was on Jefferson Street, a frame structure of 40 by 60 feet on a lot donated by Thomas Dew. The church had two wood stoves to keep it heated and was furnished with straight-back seats with the men on one side and the women on the other. As the Methodist church grew, so did the need for a building. Constructed in 1877, the stately brick structure shown in this postcard was used until 1975, when it was razed and a new, modern building was built on West Columbus Street, still used at present. (Courtesy of NPL.)

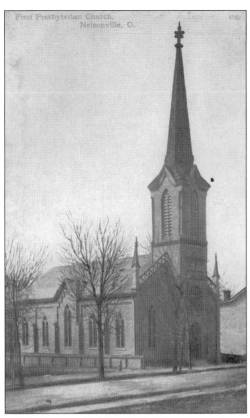

The First Presbyterian Church was founded by Rev. Thomas Downey. Built in 1872 on land donated by Webster W. Poston, the sandstone foundation was brought in via canal boats, bricks were fired in the Longstreth Brickyards in the east end of town, and the lumber was furnished by the Freer brothers. Unfortunately, Reverend Downey passed in 1869 before the present building was finished. (Courtesy of NPL.)

On January 19, 1914, the cornerstone for what began as the Apostolic Holiness Church was laid on a lot purchased on East Chestnut Street. Previously, the congregation had been meeting in Reynolds Hall uptown. Rev. J.V. Coleman arrived in Nelsonville in February 1914 to serve as the pastor. (Courtesy of NPL.)

Saint Andrews Church and the parish hall sit on East Franklin Street. Dedicated on November 30, 1893, Saint Andrews Church was built with the efforts of 100 members. The bishop at the time appointed Father W.F. Boden as first pastor of the church. (Courtesy of NPL.)

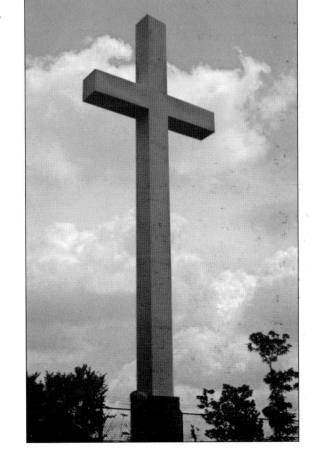

One of the tourist attractions to visit while in Nelsonville is the large illuminated cross on Kontner's Hill. Walter L. Schwartz had the cross built in memory of his wife, Elizabeth (Smith) Schwartz. It was erected in 1973 and at the time was 65 feet tall. (Courtesy of NPL.)

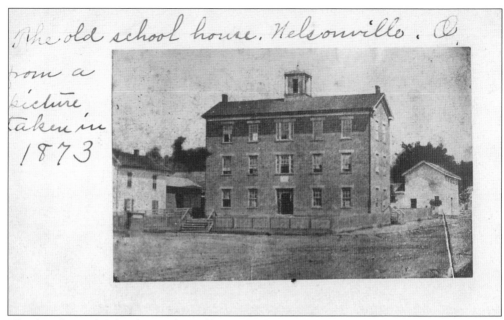

The old school house. Nelsonville. O. from a picture taken in 1873

The first Central School in Nelsonville was built in 1856 on Lot 48, which was set aside for education by town founder Daniel Nelson. This building consisted of three floors and six rooms; the first two floors housed the elementary grades, while the third floor was rented out to the Masonic lodge. The striking miners of 1884 burned down this school building. (Courtesy of Christine Vischer.)

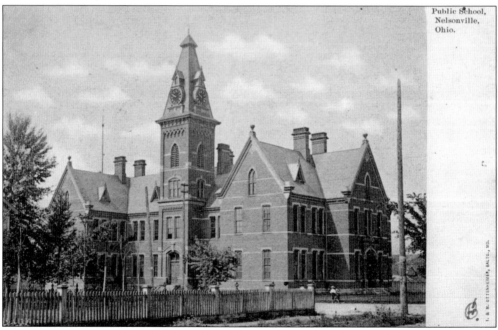

In 1885, the new Central School building was quickly constructed after the old one burned down. This stately brick building consisted of four wings and a beautiful clock tower that all of downtown could see. This building housed both the grade school and high school until the class of 1907–1908, when a new high school building was constructed. (Courtesy of NPL.)

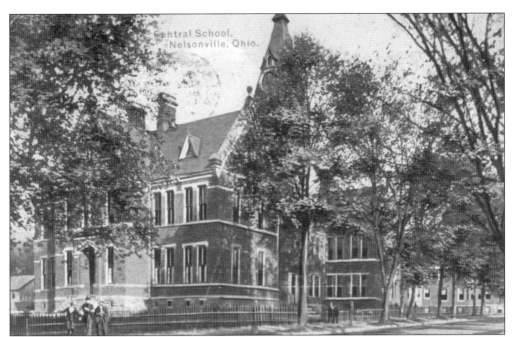

This is another view of the Central School, right along Washington Street. Many of the school's class portraits were taken outside of the building along these walls. The Old Central was in use until 1959–1960, when it was razed due to consolidation and the need for more modern structures. By the mid-1960s, Nelsonville had three separate elementary schools: Nelsonville, York, and Poston, along with a new high school located in Buchtel. The old high school building on Fayette Street was used as the junior high. (Courtesy of NPL.)

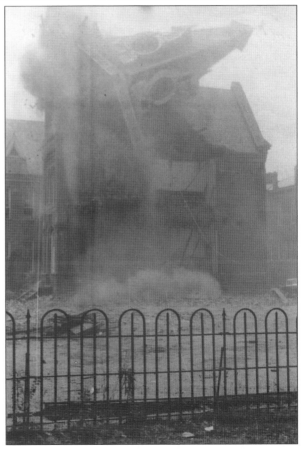

The Old Central clock tower and school bell came down in August 1960, right before the new school year. When they took down the clock steeple they found written in crayon on an old timber the names John W. Hickman, Charles F. Nelson, and Gene Barnecut along with the date October 10, 1885. By 1962, the Old Central lot had been sold to the Kroger company. (Courtesy of NPL.)

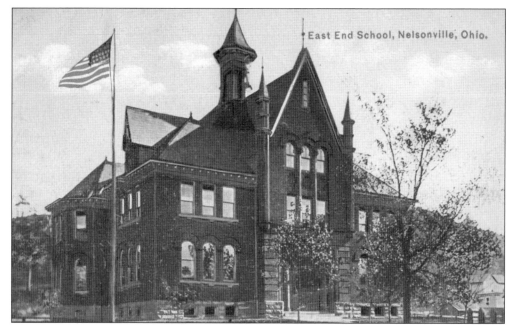

As the population of Nelsonville grew, so did the need for another school; the East End School was erected in 1894. This Gothic structure was located on the northeast corner of Second and Walnut Streets, serving the children of the east end of town. By 1959, this elementary school was torn down. (Courtesy of NPL.)

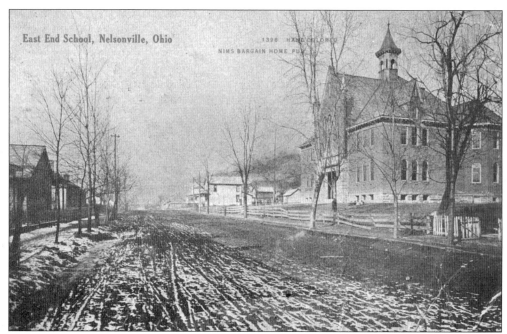

This view of the East School shows how muddy the old streets were. The school system decided it needed an east end and a west end school for the growing population of Nelsonville. It would have been a long walk for those living in the east end of town to walk to the Central School uptown, especially in bad weather. (Courtesy of NPL.)

The West End School was located on West Washington Street. It was built in 1891 and used until 1943. After the school discontinued use, it was used by the William Brooks shoe company as a warehouse until it was razed in 1970. Those who attended West End had reunions for many years; unfortunately, most of those who attended are gone now. (Courtesy of NPL.)

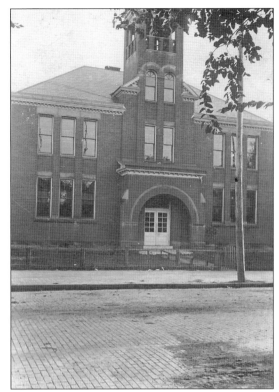

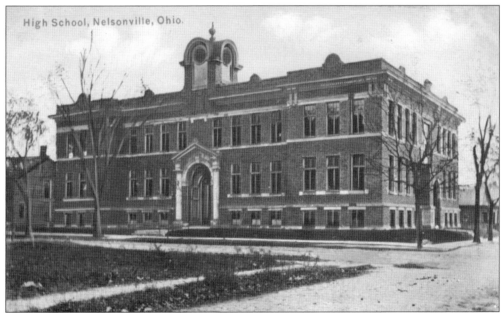

Nelsonville built a new high school in 1907, moving all the high school students from the Central School to this new school. It had a full basement, with some classrooms and restrooms. The first floor housed a cafeteria, library, office, and more classrooms, and the top floor had several more classrooms. In 1924, another addition was built on, and this became the junior high school, used up until the late 1990s. (Courtesy of NPL.)

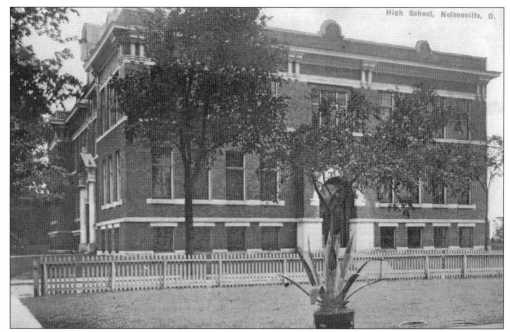

This is another view of the original high school building on the corner of Fayette and Monroe Streets. When the new half was built in 1924, the school gained a gym and auditorium. For an athletic field, the students had to walk a few blocks to the city park off Railroad Street. (Courtesy of NPL.)

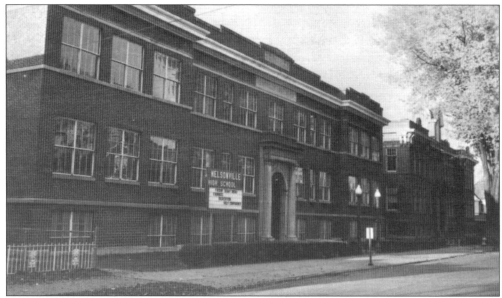

The Nelsonville High School was built in 1924, an addition to the original 1907 building. Built to accommodate more students, this building became the high school, and the original building became the junior high. This gave the elementary schools more room for the growing community. In the late 1960s, a new high school was built a few miles away in Buchtel, and these buildings were used solely as a junior high school. Today, the 1924 side of the building is still being used by other organizations, but the other half is vacant. (Courtesy of NPL.)

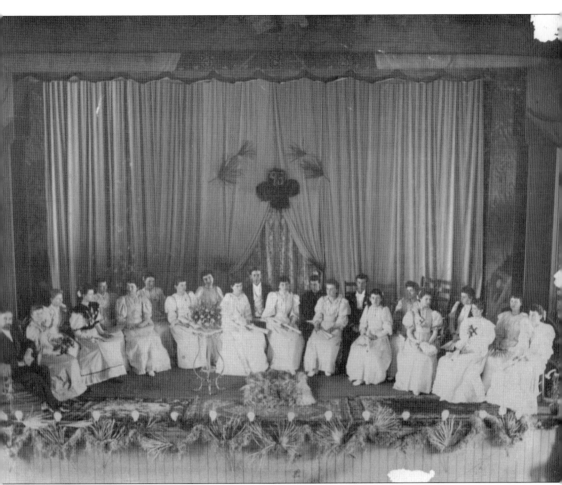

For the Nelsonville High School class of 1893, graduation was held at Stuart's Opera House. Superintendent Coultrap is the man sitting at far left. Graduates included, in no particular order, Stella Maye Allard, Ida Almira Comstock, Jeannie Beatrice Scott, Addie Cummins, Anna M. Scott, May Poston, Margaret Dew, James Benjamin Dew, Emma Raybould, Carrie Cox, Margaret Cummins, Charles Poston, Emma May Coe, Eva May Shafer, Jennie Margaret Sands, Su Ella Bryson, Rachael Charlotte Mason, Mabel Edna Gardner, and Lillian A. McNab. (Courtesy of NPL.)

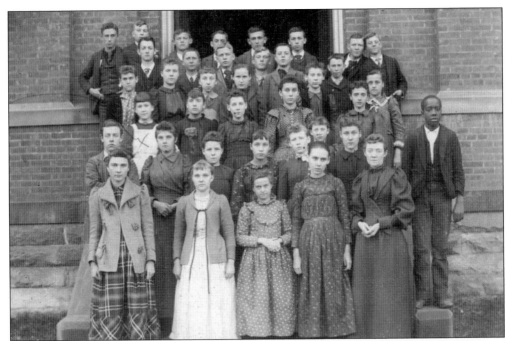

Of the students pictured here in the late 1890s, the only one identified is Mamie Barnecut Coleman, first on the left in the third row. She graduated with the class of 1898. None of these children look very happy, but it appears as if they are dressed in their Sunday best. (Courtesy of NPL.)

On the back of this photograph are the names of two teachers from the early 1900s, Miss Wright and Miss Wolfe. These were teachers from the old Central School. (Courtesy of Christine Vischer.)

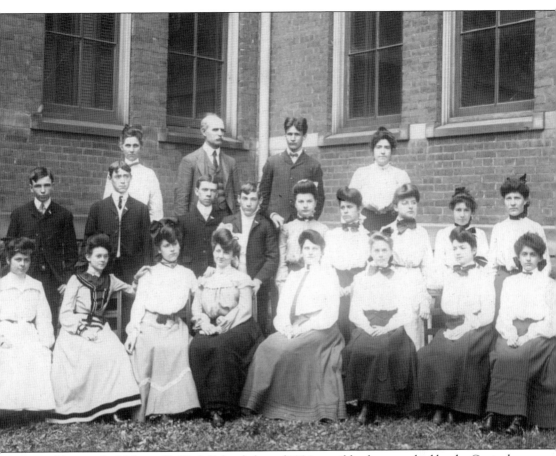

Pictured here is the Nelsonville High School class of 1904, possibly photographed by the Central School. From left to right are (first row) Ida Laws, Bessie Williams Wolfe, Bessie Hall Martin, Lillian Barnecut Aughe, Catherine Hushower Birchfield, Bertha Cummins Butt, Anna Morgan Russell, and Bess Johnson Eberle; (second row) Charles Butt, Harry Sisson, Frank Mellinger, Frederick Marsh, Mable Verity Hooper, Mary Morgan Pritchard, Sadie Stoneburner, Edith Cox Wallace, and Velma Dowler Pritchard; (third row) Miss Biggs, Prof. Aaron Grady, Superintendent B.A. Place, and unidentified. (Courtesy of Christine Vischer.)

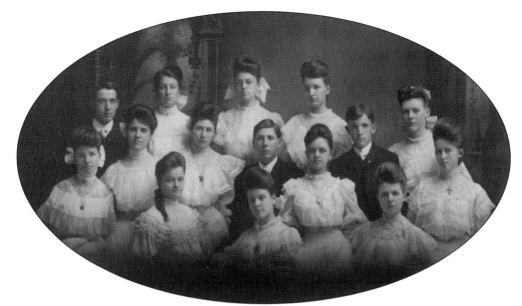

Pictured here is the Nelsonville High School graduating class of 1905. The class included, in no particular order, Ila Landis, Harry Hickman, Minnie Coy, Ruby Menzie, Hattie Saunders, Irene Scott, Mable Coakley, Bertha Howards, Eugene Shafer, Helen Johnson, Roy Young, Adeline Vorhees, Vivian Wells, Maggie McLaughlin, and Bertha Marsh. (Courtesy of NPL.)

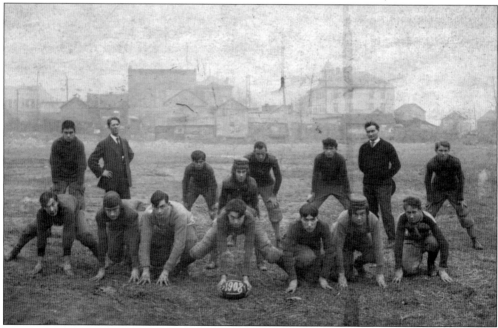

Members of the Nelsonville High School football team of 1908 are pictured here from left to right: (first row) Harold Mechem, Joe Barnecut, Henry Stratton, Warner Green, Russ Lamborn, Charles Preston, and William Meek; (second row) Raymond Bethel, Otto C. Jackson, Frank Freer, Berry Pritchard, Jay Hoodlet, Arthur Stratton, Dr. William H. Cann, and Erle Jackson. This photograph was taken in the Baird Lot, where the Nelsonville Aquatic Center and city park are now located. (Courtesy of NPL.)

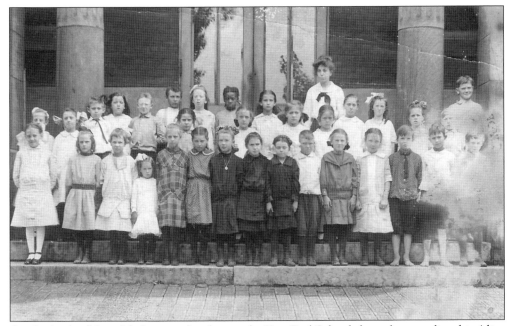

On the back of this old photograph taken at the East End School the only name listed is Alice Keating, grade three. According to the census, Alice Keating would have been a third grader at this time. There are not many surviving images of the East End School. Some of these children are dressed up in their Sunday best, and a couple of the boys are barefoot. (Author's collection.)

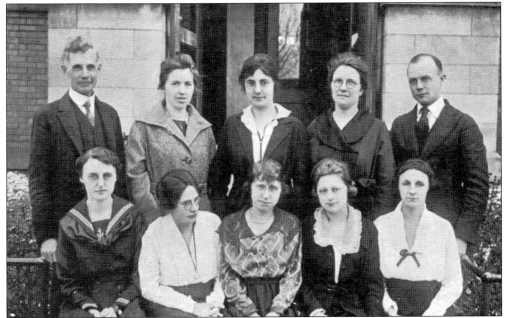

The Nelsonville High School faculty in 1920 included, from left to right, (first row) Altha Rickards, commercial; Donalda Smith, chemistry; Claire Hoffert, Latin; Florence Parks, English; and Helen Crawford, French; (second row) Daniel A. Ferree, superintendent; Mable Rickenbacker, history; Grace Loofbourrow, general science; Verna Lane, physics and geometry; and James L. Fri, principal. (Courtesy of NPL.)

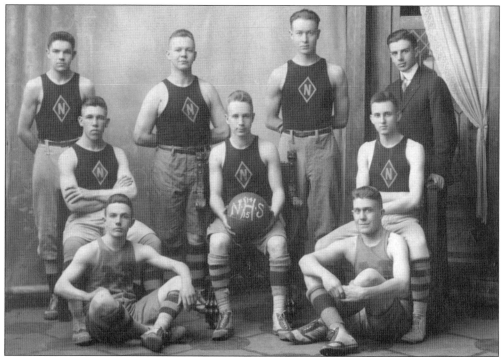

Pictured here is the Nelsonville High School basketball team for the 1914–1915 school year. From left to right are (first row) Donald Lowden and George Barrows; (second row) Everett Kontner, Gilbert Love, and Fred Edington; (third row) Glenford Dugan, Don Davis, Clermont Howell, and coach C.C. Lake. (Courtesy of NPL.)

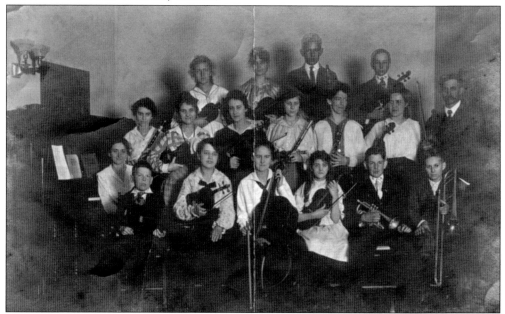

The Presbyterian church had a Sunday school orchestra run by John Scott. Those identified in the photograph are John Scott, second row on the far right, Geneva Scott, center front holding a cello, and Scott's daughter Eleanor Scott, to her left. (Courtesy of NPL.)

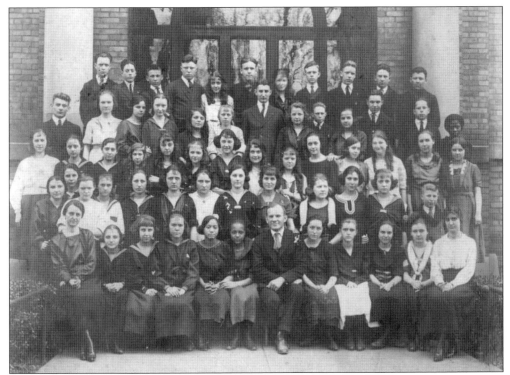

Pictured here is the Nelsonville High School class of 1923 as sophomores in 1920–1921. In the first row on the left is Altha Rickards, commercial teacher. The only man in the first row is H.C. Skinner, the principal, and at far right in the first row is Julia B. Clark, listed as French teacher in the 1921 yearbook. This photograph was taken in front of the junior/senior high school building on Fayette Street. (Courtesy of NPL.)

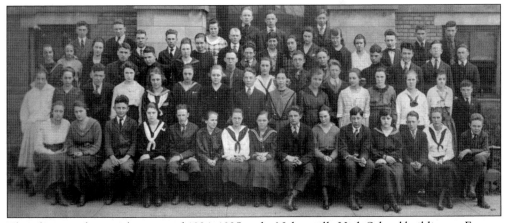

This photograph was taken around 1924–1925 at the Nelsonville High School building on Fayette Street. In many of these old photographs, the teachers seem to be hiding in the middle or back. Here, two of the teachers are in the fourth row at center, and one, science teacher Cal Biefield, is in the third row at far right. (Courtesy of NPL.)

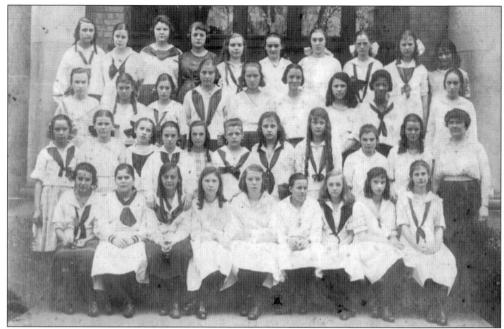

In the 1920s, the local schools had many clubs for students to join. These girls are all dressed in white with a dark scarf/necktie. According to a 1921 yearbook, these girls might have been members of the Adelphia Literary Club. The club strived to improve skills in public speaking, music, and dramatic arts. (Courtesy of NPL.)

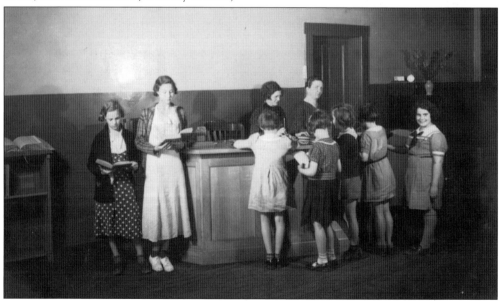

In 1936, the public library was located in the Central School on the public square. The librarians behind the desk are Dorothy Wightman (left) and Nellie Dowler. The Nelsonville Public Library still has the circulation desk and dictionary podium pictured here. Dorothy Wightman (1895–1966) was a librarian in several states during her lifetime, from Pennsylvania to North Carolina. Wightman spent her last years in Duplin County, North Carolina, where the county's library was named after her. (Courtesy of NPL.)

Eight

RECREATION

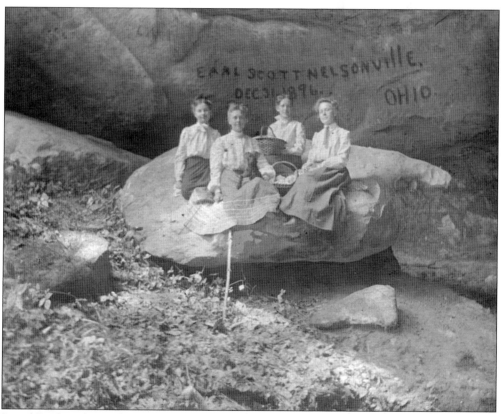

Initial Rocks is located off State Route 278 heading from Nelsonville to Carbon Hill. This area was within walking, or rather, hiking distance from town. It became a highly popular getaway for church groups, school groups, family picnics, and couples enjoying an afternoon together. Many visitors liked to carve their names into the rocks just like Earl Scott (1874–1965), who carved his name on December 31, 1896. Maybe there was a party at Initial Rocks that night to ring in the new year of 1897. (Courtesy of Christine Vischer.)

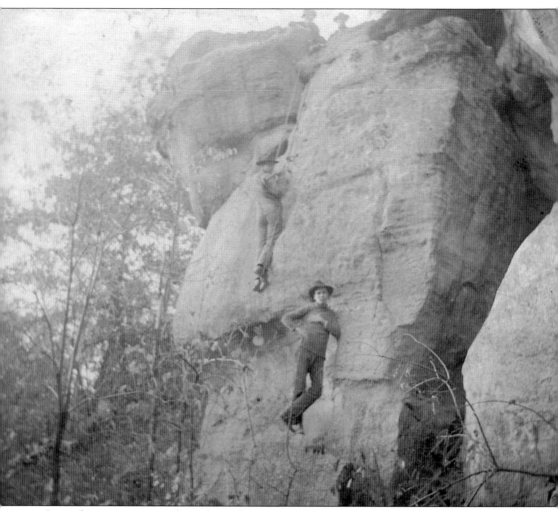

Some daring young men from the early 1900s are hanging out on Initial Rocks, a popular spot for the youth of Nelsonville. Some of the nicknames for the rock formations located in this area were Devils Table, Fat Man's Squeeze, and Lover's Leap. Later, when the Air Force survival camp came to Dorr Run, the area was used for lessons on how to scale cliffs and survive in the woods. (Courtesy of Christine Vischer.)

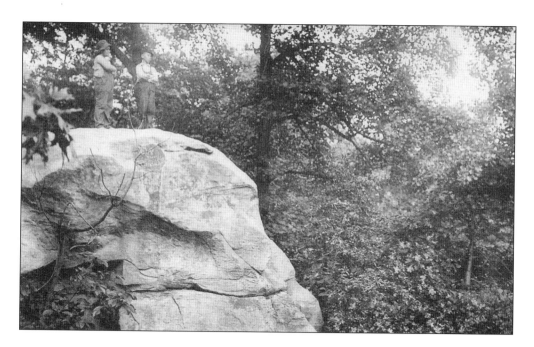

On Sundays, many of the residents of Nelsonville, nearby Carbon Hill, and Dorr Run would hike up to Initial Rocks to spend a relaxing afternoon. Young couples would come up and carve their initials with a heart into the bark of an old beech tree, maybe swing like Tarzan from one of the grapevines, and watch the view from Saddleback Hill, so named because of its slope. One of the most popular rocks to hang out on, due to it being the easiest to climb, was Devils Tea Table. (Both, courtesy of NPL.)

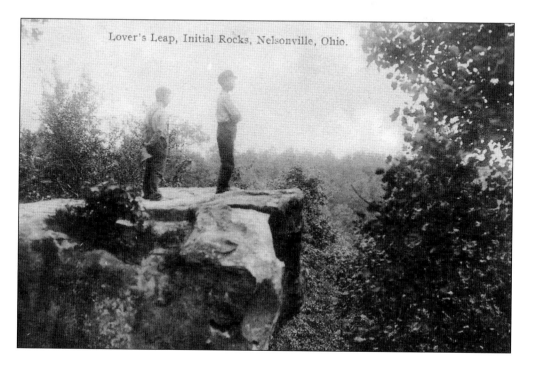

Lover's Leap, Initial Rocks, Nelsonville, Ohio.

Before Nelsonville was settled, the Delaware and Wyandot Native American tribes roamed the area. One of the stories they left behind was the legend of Elm Rock. The tale is a forbidden love story of an Indian brave who falls for a maiden, a match the chief was not happy about. He said that if an elm tree could grow and split a large boulder open in 12 moons, he would not have to split open the brave's head by tomahawk. Unfortunately, it took an extra 12 moons for this to happen, and the brave lost his life, but the real moral of the story is never to rush Mother Nature. Elm Rock was featured in *Ripley's Believe It or Not!* in 1931. (Courtesy of NPL.)

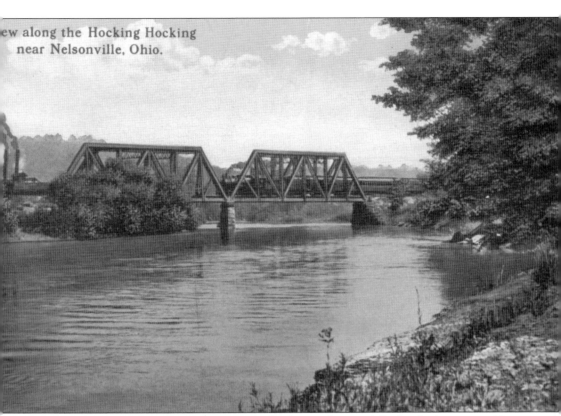

ew along the Hocking Hocking
near Nelsonville, Ohio.

Here is a view from the Hocking River; in the background, one of the brick plants is visible.
Several of the old bridges are still standing and can be seen when the leaves are off. The Black
Bridge is still in use and can be seen by Nelsonville City Hall. (Courtesy of NPL.)

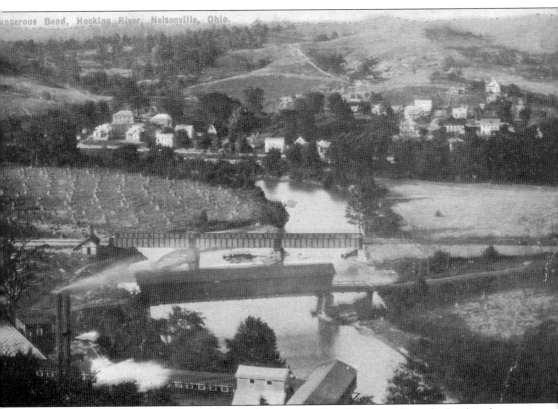

Now State Route 278, this road takes residents over to East Clayton, where the brick industry was centralized. In the background is the west end of Nelsonville; the railroad bridge, also called the Black Bridge; and the covered bridge (built in 1875), which is now State Route 278. On the left in the distance is the Athena brick plant, where the present-day VFW building sits. (Courtesy of NPL.)

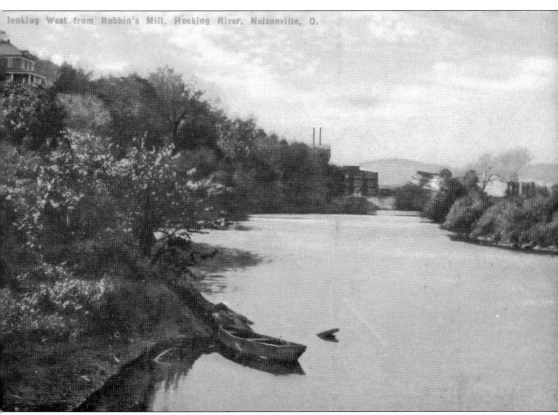

looking West from Robbin's Mill, Hocking River, Nelsonville, O.

This is another view looking toward the Athena brick plant; many of the locals fished from the river and swam when it got too hot in the summertime. This scene has not changed too much. (Courtesy of NPL.)

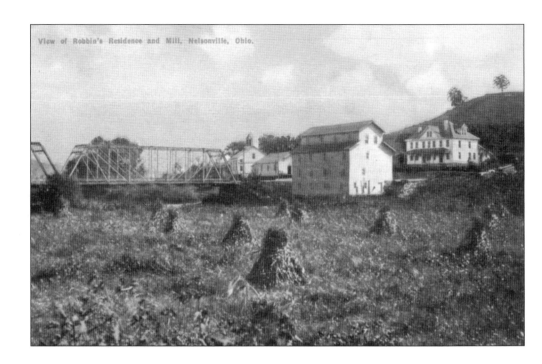

Across the Hocking River, the Robbins Mill used to sit on what is now Hocking Parkway. The mill that can be seen in both photographs was originally built in 1816 by Josiah Coe as a flour mill. Later it changed hands and was run by Charles Robbins, whose family came to Nelsonville in 1822. Many of the homes across the river were company houses. Charles Robbins was a prominent businesses owner and owned Robbins Dry Goods and Groceries. (Courtesy of NPL.)

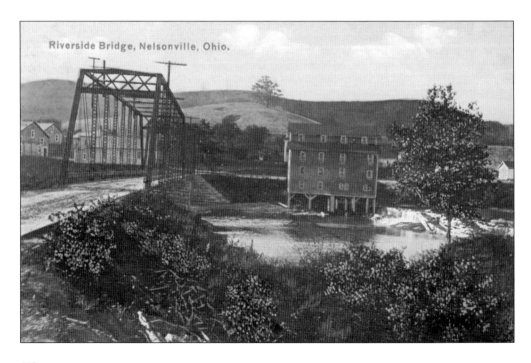

The old Iron Bridge was built in 1889, one of several bridges that stood here. The first bridge to span the Hocking River here was built by a collection of subscriptions from local businesses and townspeople. Subscriptions ranged from 50¢ to $20, and some promised to pay their subscription in labor or goods. This photograph was taken in 1982, when the new bridge that stands today was built. (Courtesy of ACHS&M.)

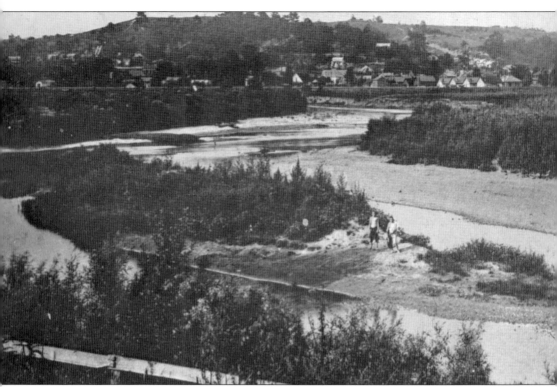

During the summer, the Hocking River was a very popular place to cool off. According to the old-timers, there were five well-used swimming holes. The sandbar located near what they called the playground or Crabtree Field was one, and the Black Bridge was mostly used by the kids who lived in District 29 until a boy broke his neck there. The Black Bridge area often used by the YMCA for swimming lessons was one of the more dangerous places due to a deep pool under the bridge. In the Myers Street area was the Rocks, a narrow channel; if a train came along, swimmers had to jump to safety. Last but not least was the area known as the Riffles near the south corner of the athletic fields, very shallow and more like a wading pool. Unlike the swimming pools of today, there were no changing rooms or fancy bathing suits; most changed in the bushes and wore whatever old clothes they had, but on a hot summer day, nobody minded. (Courtesy of NPL.)

Nine

EVENTS

On May 17, 1912, Theodore Roosevelt paid a visit to Nelsonville on his campaign trail. Just a week or so before, William Howard Taft had also spoken from the Dew House. This brought the total number of presidents who had visited the Dew House up to four: William McKinley in the 1890s, Warren G. Harding in 1910, and then Roosevelt and Taft in 1912. (Courtesy of ACHS&M.)

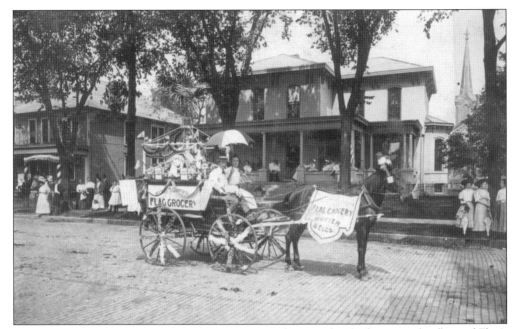

This early 1900s parade was possibly held during the Fourth of July, since the float of Flag's Grocery is decorated in a patriotic way. This photograph was taken on East Columbus Street in front of the Cable House. In more recent times, Nelsonville has a grand parade every August to celebrate the Parade of the Hills. (Courtesy of ACHS&M.)

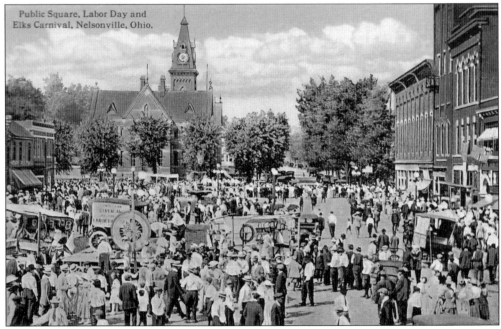

The city of Nelsonville was celebrating the Elks Carnival. It looks like fun was had by children and adults alike. Every year in mid-August, the town has a similar celebration called Parade of the Hills. There are carnival games, rides, and nightly entertainment. Many old residents of Nelsonville who have moved away mark their calendars to come back and celebrate. (Author's collection.)

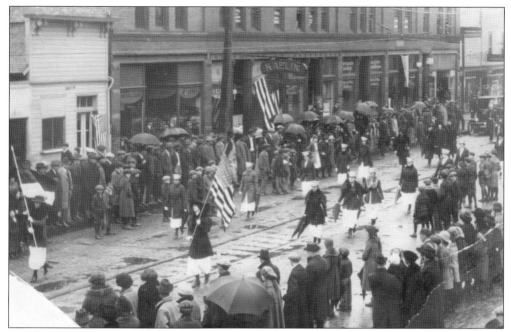

Marching down Columbus Street was a parade possibly to welcome home World War I soldiers. In the background are the Kaelin jewelry store and the Maple Hill company store. This photograph had to be taken between 1910 and the early 1930s due to the tracks of the Hocking–Sunday Creek Traction Company running down Columbus Street. (Courtesy of ACHS&M.)

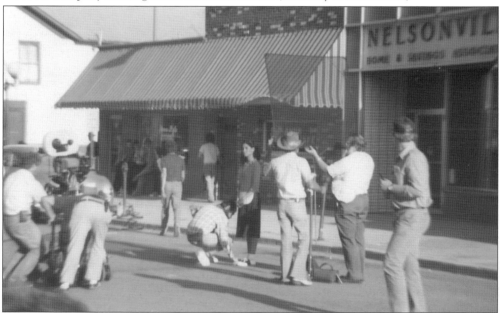

In the spring of 1984, Hollywood came to town. The movie *Mischief* was filmed on the public square. In this photograph, actress Jami Gertz can be seen filming in front of the Nelsonville cable office and the Nelsonville Home and Savings Bank. Jami played Rosalie, a small-town girl who worked at the local café. This was a very exciting time for Nelsonville; the whole town was sent back in time to the 1950s. (Courtesy of Linda Westfall.)

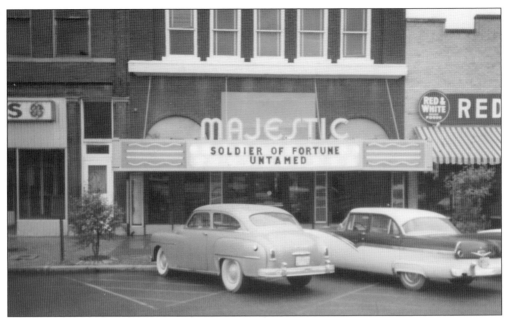

At one time, Nelsonville had a couple of old movie theaters uptown, the Majestic and the Orpheum. When Hollywood came to town, they transformed the old Majestic Theater (or at least the outside) to look like it did in its heyday. The theater had been closed for many years, but by 1990 it was opened back up once again; paired with Pizza Crossing, it was a great place for an evening out. (Courtesy of Linda Westfall.)

When *Mischief* came to town, it gave Nelsonville new life. Many locals applied to be extras in the movie; the town was at one point set up to look like a street carnival, and everyone came out to watch the filming of each scene. Some of the actors and actresses were just beginning in their careers: Kelly Preston, Catherine Mary Stewart, Doug McKeon, Chris Nash, and Jami Gertz were all main characters in the movie, and several can still be seen on the big screen. (Courtesy of Linda Westfall.)

The Hoodlett's Department Store was turned into a fictitious store by the name of Brubaker's for one of the scenes. Some of the local schoolchildren often talked their teachers into taking them on a mid-afternoon walk after lunch to watch the action on the square. Not all of *Mischief* was filmed in Nelsonville; some of the scenes were also filmed at Canal Winchester, about 45 minutes up Route 33. (Courtesy of Linda Westfall.)

The Dew House again makes a grand appearance for *Mischief.* One of the scenes that was filmed involved a car chase with the cars driving under the Dew House Porch and on the sidewalk. From recruiting Civil War soldiers to mine strikes, shoot-outs, presidential campaigns, and now Hollywood, the Dew House has seen it all—if only the walls could talk. (Courtesy of Linda Westfall.)

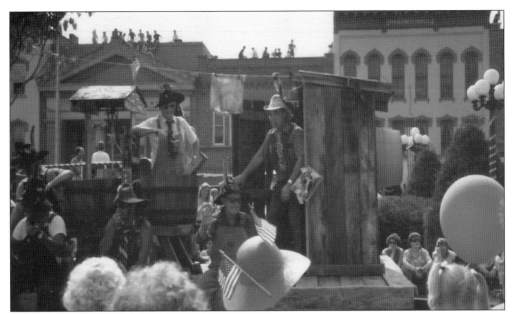

Nelsonville was on the map by 1985, when the popular game show *Wheel of Fortune* decided to film a commercial here. Still excited from all the famous actors who had visited just a year ago, now Nelsonville got to welcome Vanna White and Pat Sajak to town. No better way to introduce them than to have a parade. (Courtesy of Linda Westfall.)

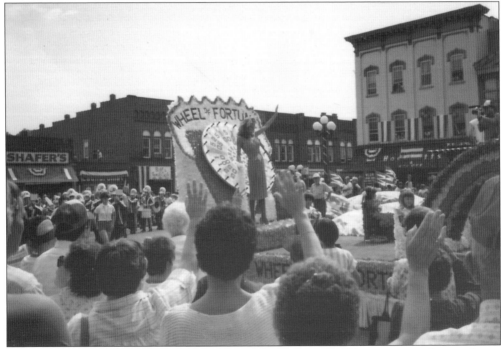

Everyone wave, Vanna White is here to see Nelsonville, a small but increasingly popular to Hollywood small town. Over the years, Nelsonville has been featured in a couple of other small independent films or student documentaries, but nothing compares to watching Hollywood film in one's hometown. (Courtesy of Linda Westfall.)

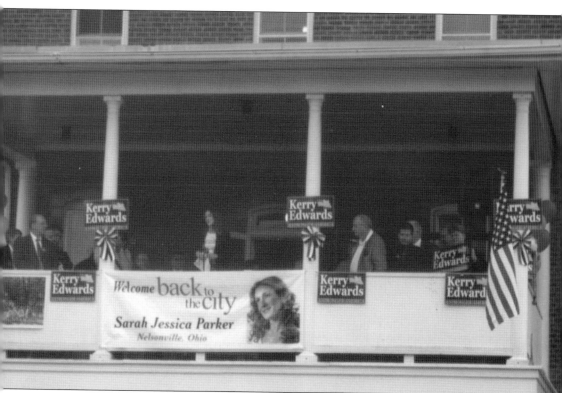

Sarah Jessica Parker, of *Sex and the City* fame, came to visit Nelsonville in October 2004 to campaign for Democrat John Kerry. Parker was born in Athens County, Ohio, on March 25, 1965, one of eight children to Barbara (Keck) and Stephen Parker. Her mother was a schoolteacher at the time. Although Sarah did not live in Nelsonville long (her family soon moved to the Cincinnati area), the town still claims her as one of its own. (Author's collection.)

DISCOVER THOUSANDS OF LOCAL HISTORY BOOKS
FEATURING MILLIONS OF VINTAGE IMAGES

Arcadia Publishing, the leading local history publisher in the United States, is committed to making history accessible and meaningful through publishing books that celebrate and preserve the heritage of America's people and places.

Find more books like this at
www.arcadiapublishing.com

Search for your hometown history, your old stomping grounds, and even your favorite sports team.

Consistent with our mission to preserve history on a local level, this book was printed in South Carolina on American-made paper and manufactured entirely in the United States. Products carrying the accredited Forest Stewardship Council (FSC) label are printed on 100 percent FSC-certified paper.

MADE IN THE